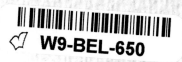
PRACTICAL COURSE IN
WATERCOLORS

Fig.1. Ester Llaudet. *Winter landscape.* **Artist's private collection. In this watercolor, described step-by-step on page 71, we can see how the artist goes about painting the vegetation in this way: she paints the details of this landscape as mere abstract shapes, and avoids using a methodical, realist approach.**

Fig. 2. Ester Llaudet. *Copy of a landscape by Van Ruysdael.* How to make a copy of a highly detailed Dutch landscape is discussed on pages 86 to 89. This gives us an ideal opportunity to analyze wet brush and dry brush techniques. It also serves as a demonstration of how to base your work on a well-known oil painting.

PRACTICAL COURSE IN
WATERCOLORS
LANDSCAPE TECHNIQUES
JOSÉ M. PARRAMÓN

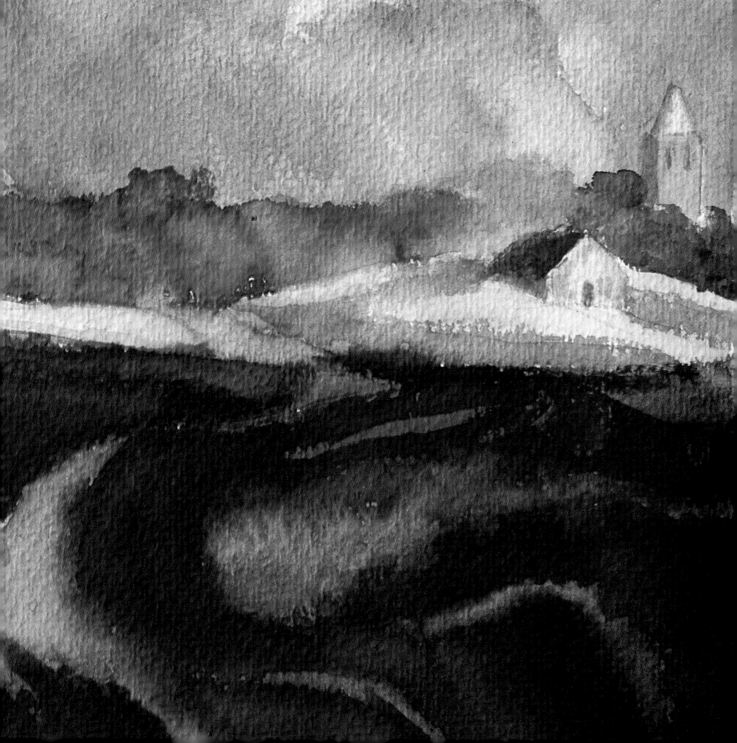

Fig. 3. Gasper Romero. *Path leading to a farmworker's house.* Artist's private collection. Gasper Romero's work will be very useful when it comes to explaining how to integrate different elements of a landscape, in this case the grass verge of the path and the trees.

General editor: José M. Parramón Vilasaló
Text: José M. Parramón
Editing, layout and dummy: José M. Parramón
Cover: J. Gaspar Romero y José M. Parramón
Translation from the Spanish: Monica Krüger

Photochromes and phototypesetting: Novasis, S.A.L.
Photography: Estudio Orofoto

1st edition: February 2000
© José M. Parramón Vilasaló
© Exclusive edition rights: Ediciones Lema S.L.
Edited and distributed by Ediciones Lema S.L.
Gran Via de les Corts Catalanes, 8-10, 1st 5th A
08902 L'Hospitalet de Llobregat (Barcelona)

ISBN 84-89730-88-1

Printed in Spain

Table of Contents

3

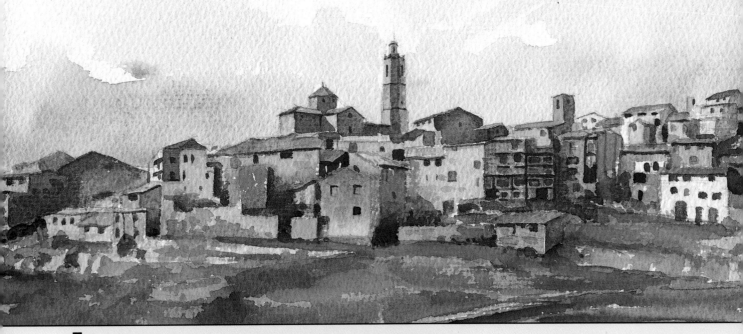

5

Fig. 4. Jordi Segú. *View of a town*. Artist's collection. As with all of Jordi Segú's watercolors we can admire his drawing skills and his ability to deal with size and proportion, which, in this case, are complex challenges. He then goes on to apply color with the richess and fluidness which are the hallmarks of a skilled watercolorist.

Fig. 5. José M. Parramón. *Farmhouse in the district of la Seo de Urgel* (Spain) (detail). Artist's collection. The outstanding thing about this example is the contrast of colors, echoing Cézanne's train of thought expressed in his writings when he stated: "Contrast is of paramount importance. It is not just black and white which make for contrast, but the relationship between different colors".

Introduction

You're on a journey. You've loaded up the car with everything you'll need to paint watercolors: an easel, paintbox, paintbrushes, board, paper, a waterbottle and a plastic container. Imagine you're travelling along a road, Castilla la Vieja in Spain, for example, trying to come across something ("*I don't look for things, I come across them*", **Picasso** said). Yes, hoping to chance upon a subject, a landscape to paint in watercolor. It's 11 o'clock in the morning on a sunny day in August. On your right stretches an infinite succession of wheat fields, under sunlight which brings out the golden yellow of freshly cut sheaves with their ears of corn. "Everything's the same color, or nearly. There's no contrast. Too much unity", you think to yourself. You may recall the words of **Cézanne**: *"Contrasts and relations between colors: that is the key to all painting. Put another way, it can be said that painting is the process of creating contrasts".*

And you continue, accelerating to leave the monotonous shapes and colors behind until, after a few bends in the road, the outlook of the landscape changes: the wheat fields are now alternated with strips of grassland and patches of fallow land, interrupted by lines of trees and bushes, the horizon is capped by a chain of mountains "A prime example of unity within variety" you reason to yourself. *Unity* is provided by the geometry of shapes; the squares and rectangles of the fields and strips of ground, while *variety* is provided by the diversity of forms and colors.

But you are still not quite satisfied. The landscape that you are surveying is too flat. So, you keep on going, in the hope that you'll come across an incline, a raised viewpoint which would enable you to see your subject matter from above, more of a bird's eye view.

A quarter of a mile further and... at last, a steep hill and an outcrop, a viewpoint which allows you to see the scene from the best angle, enhancing the colors and shapes: the wheat fields with their sheaves (ochre and yellow), strips of grass (permanent green and ochre), trees, bushes (red carmine and ochre in the light, emerald and red carmine in the shadows), the mountains in the far distance (ultramarine and burnt umber, together with the white of the paper to obtain the right blue-gray tone).

So, you park on the shoulder and set up the easel, board and paper, arrange your paints, the brushes and the water; get out the folding chair and sit to take in and consider the various composition options you have and how you will interpret the scene. You may recall a work by **Van Gough**, *The meadow*, and decide to raise your horizon, giving minimal space to the sky. Outline the edges of the fields and strips of ground and consider how you would apply the theory of *near and distant colors*, employing a yellow ochre in the foreground, light burnt umber in the middle ground followed by a deeper umber, then light and dark green in the background, blues and grays dominate the far distance. You see on your right a tree, a fair-sized evergreen oak, which you place in the foreground on the left of the picture. In this way you create a foreground that accentuates the depth of your landscape.

It's half past eleven in the morning and the sun is reaching its summit. The light falls directly on the subject matter, prompting you to use flat colors, with hardly any shadows, approaching the painting in a colorist manner.

Finally, you take a pencil and start to draw, so that you can move straight on to painting.

Wait! Are you going to paint just like that, without making any preparatory sketches? That's a bad idea; preparatory sketches are one of the most important steps to painting watercolor landscapes. Never mind; you may be

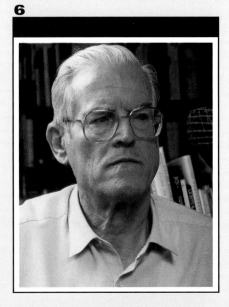

Fig. 6. José M. Parramón, author of more than forty five books teaching drawing and painting, which have been translated and published in over fifty countries, including France, Great Britain, Germany, Italy, the United States, Japan and Russia.

unaware but you are following the precedent of Claude Monet, who, in his old age wrote to his friend Gustave Gefroy from Giverny: *"I do all I can to let my work take shape from nature but nevertheless, let me tell you, in order, to achieve this, I often completely do away with the rules of painting".*

Just as you have done. With luck and with or without a preparatory sketch you will succeed both with this work and with all your watercolor landscapes.

José M. Parramón

Fig. 7. In this watercolor by Merche Gaspar (*Tropical beach*, artist's private collection), reproduced on page 14 of this book, we can see how the artist uses the direct light on the scene and the contrasts between the sunlight, bleaching the sand, and the shadows cast by the palm trees.

LIGHT AND SHADE IN LANDSCAPE PAINTING

If you pause to take a look around, you will see that the volume and the shape of objects is the result of the interplay of light and shadow on surfaces. The influence of light, shade and chiaroscuro are key factors which must be taken into consideration when recreating the sensation of volume in any landscape. In order to fully understand how light gives shape to objects, you must previously learn the key characteristics of light, analyzing the different types of shade; the direction, quantity and quality of the light, and how to draw shadows in perspective. The following section attempts, in a straightforward way, to guide you in your study of these basic principles. In this way you will quickly learn to apply these lessons in your own watercolor landscapes.

Shadow, Projected Shadow and Reflected Light

When you paint or draw, shadows cannot be ignored, especially since they create shapes as interesting, compositionally speaking, as the shapes of the objects you are studying.

Sunlight tends to cast stronger, sharper shadows than artificial light. Shadows created by the sun alter as the earth turns causing them to vary in shape and length as the day progresses. For example, when the sun is on a level with the horizon, the shadows cast by the subject will be long (fig. 9); if the sun is about 45° above the horizon the shadows created will be shorter (fig. 10). When the sun is at its peak, at midday, the same object will cast hardly any shadow at all (fig. 11).

9

10

12

Figs. 9 to 11. The position of the sun at different hours of the day will alter the direction and shape of the shadow cast by an object.

11

Fig. 12. See in this photo how the evening light creates elongated shadows as a result of the light source being low, just above the horizon.

Next, we will examine the different variables that cause shadows to appear on objects. When you place an opaque object in front of a light source, a dark zone is created on the side of the object facing away from the light source. We call this *direct shadow* (fig. 13). At the same time, the same object casts a shadow on the surface it rests on. This silhouette may not be the same shape as the object: it may appear mis-shaped depending on the position of the light source in relation to the object. We call this area of shadow *projected shadow* (fig. 14). Now imagine that the still life is lit as before but with the addition of a secondary source, provided by the introduction of a white reflective screen. Light emanating from the source reaches the screen and is projected onto the objects, throwing light onto the shadows (fig. 15). This complementary source is called *reflected light*, it indirectly lights the shaded parts of the subject. Reflected light helps us to understand the shape of forms, it emphasizes their volume.

It is therefore necessary to bear in mind how the light reflected from objects in close proximity to each other can often act as an additional light source.

Fig. 13. The still life is lit by a light source located above it, to the left. See how this creates a shadow down the right side of the objects facing away from the light source.

Fig. 14. Lit with the same light source. This time, by lowering angle of the light, we can make the shadows projected onto the surface more elongated.

Fig. 15. The reflected light or complementary source indirectly lights the parts of the objects in shadow.

13

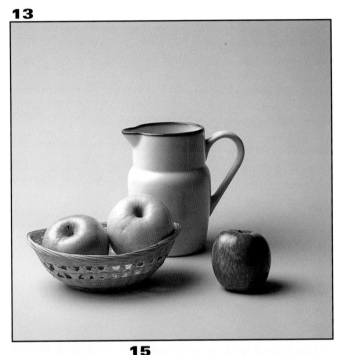

14

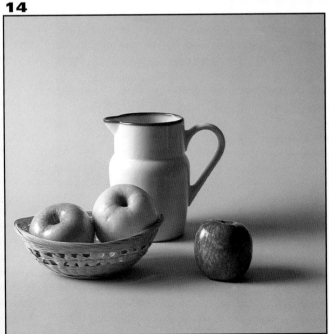

15

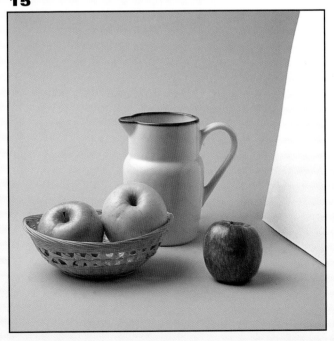

Lighting Direction

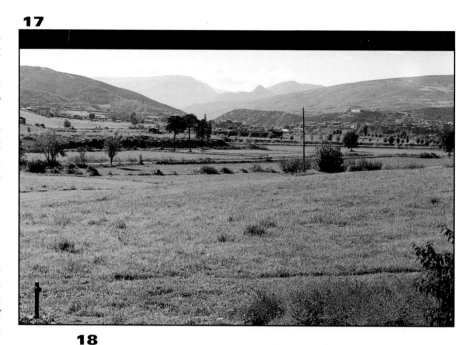

The landscape's appearance alters depending on the direction of the light and the time of day. These factors will create the illusion of volume and depth by casting shadows which also add expression to the scene.

There are three general principles which determine the effect that light creates on landscape and thereby, on the quality of the tones and shadows which are derived from this light:

— **the direction of the light**
— **the quality of the light**
— **the intensity of the light**

In this chapter we will analyze the first of these factors. Light can be classified as proceeding from any one of five possible directions, each of which has a particular way of creating volume, producing a distinct effect on the landscape.

Frontal light source: light hitting the subject straight on, i.e. with the sun at your back. In this case the shadows are hidden behind each of the objects making up the scene. Observe that there are hardly any shadows in view (fig. 17) and the sensation of depth and volume is not marked to an extent.

Overhead light source: in this case the sun is at its peak at midday, or there is any elevated light source above the subject. Given the resulting absence of shadow, this light is ideal for drawing or painting. While the sun is in such a high position, any shadows will project downwards and are often hidden directly under objects which cast them (fig. 18).

Figs. 17 to 21. Subjects illuminated from various positions: scenes lit from the front, overhead, from the side, from below and backlit.

19

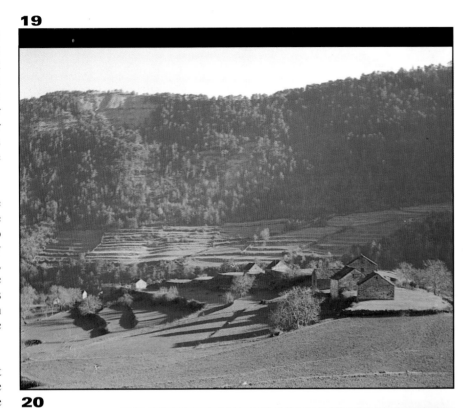

Side light source: the light falls onto the landscape from one side, with the result that half of each object is lit while the remainder is completely in shadow. The most characteristic example of this is when the sun is near the horizon, i.e. as dusk is falling or just after sunrise. The closer the sun is to the horizon the more elongated the shadows become (fig. 19).

Uplighting: the light in this case seems to emanate from below the position of the subject. This is due to the fact that the sun is reflected by surfaces such as rivers, lakes, the sea, snow or white sand on a beach. The reflection of sunlight on surfaces lights the subject from below and can add an element of drama to the scene (fig. 20).

Backlighting: when the subject is lit from behind it casts much of what the artist sees into shadow. Landscape appears as a dark silhouette, with hardly any contrast in color or tonal shades (fig. 21).

20

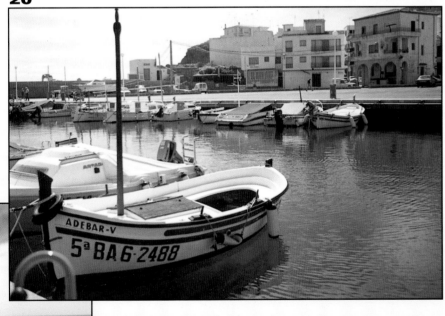

21

Quantity and Quality of Light

In addition to the direction of light source, there are other decisive factors that allow the artist to interpret the variations between light and shadow: the quantity and quality of light.

The quantity of light. This determines the amount of contrast between the well lit areas and those in shadow. If we bring a 25 Watt lamp up close to the subject, it will cast more intense shadows, which are sharp and more clearly defined than when the subject is lit by natural or diffused light, which lessens the contrast and softens the intensity of the shadows. If the source which lights the subject is too intense it can "flatten" the image, as the sense of volume diminishes.

22

23

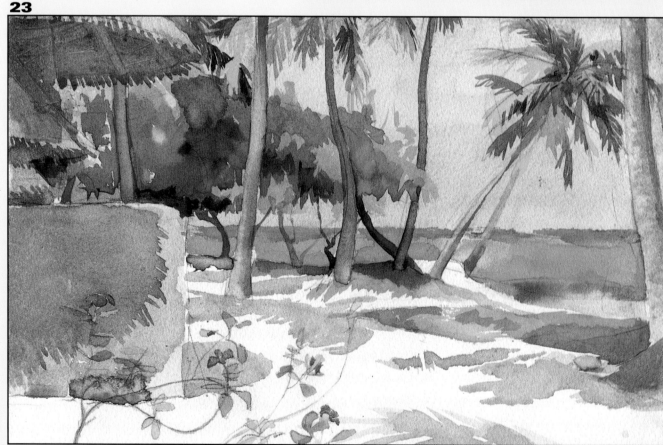

Fig. 22. The model is lit directly by a small 25W lamp which produces sharp contrasts where the light falls.

Fig. 23. Merche Gaspar's watercolor is an example of the effect of direct light on an outdoor scene. See how the sunlight reflects off the sand and how the palm trees project shadows onto it.

24

25

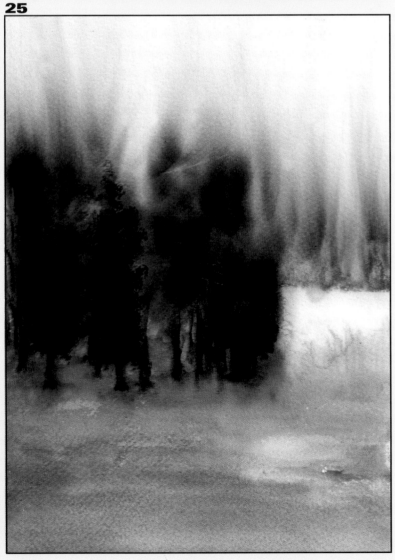

However, if the subject is lit with a dim light, this creates little contrast between areas of light and shadow, and no reflected light whatsoever.

The quality of light. This strongly influences the quality of the light and shadow and the degree of contrast between them. Two different types of light should be considered:

— *Direct light:* When natural or artificial light falls directly on the subject it creates intense shadows and sharp outlines. Its main characteristic is that of strong contrast and an absence of half-tone shadows (fig. 22, facing page).
In figure 22 we can see strong clear-cut shadows, which contrast with the brightly lit surfaces. Direct light comes from concentrated artificial light or intense sunlight coming in through a window.

— *Diffused light:* For example the light that falls on a landscape on an overcast day (or when the sun is behind the clouds), or alternatively, the diffused light of a strip-light or any artificial light behind a shade, which creates a similar effect. Diffused light emanates from a source that is uniformly filtered creating a gradual transition between areas in light or shade, thus giving rise to a richer variation of intermediate tones (fig. 24).

Fig. 24. Diffused light, such as that projected, for example, through curtains at a window or from the sun half obscured by cloud, casts shadows that are less sharp and less dense.

Fig. 25. The mist that hangs over the countryside during the early hours of the morning is another good illustration of this diffused light, as can be seen in this watercolor by Ester Llaudet.

The Perspective of Shadows

The light projected by the sun travels in a straight line, and radiates outward. However, the huge distance dividing the earth from the sun effectively eliminates the effect of the light radiating outwards. Therefore, we say that when sunlight falls on an object the sun's rays are travelling in parallel lines. When an object is viewed from above, the shadows will be projected in parallel perspective onto the surface on which the object rests (fig. 29). We can therefore conclude that:

**The size and dimensions
of a shadow projected
by an object placed in the sun
will depend on the sun's position
in the sky, the position
of the artist in relation to
the picture plane, the time
of day and the shape
of the object.**

This is made clearer by the examples, which illustrate through the use of parallel lines how different shadows are cast.

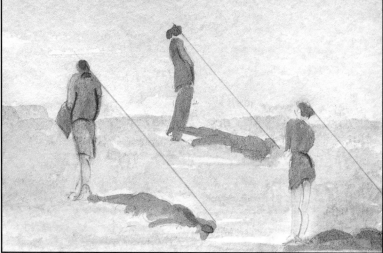

Figs. 26 to 28. The shape of the shadow is determined by the sun's position in the sky, the higher the sun is, the less elongated the shadow will be.

Fig. 29. Given the distance between us and the sun, its rays are travelling in parallel lines when they hit an object; the resulting shadows from these objects are therefore projected parallel to one another.

30

31

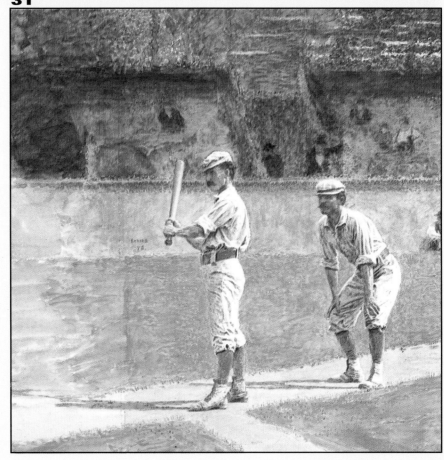

Figs. 30 and 31. Study the treatment of shadows in this two examples. The first scene is a watercolor by Edward Bawden, *Gallabat, guns firing on Motamma*, Tate Gallery, London, which represents a desolate landscape in which the sun (low in the sky) casts shadows created by the trees in the foreground (fig. 30). The next example is *The baseball players* by Thomas Eakins, Rhode Island School of Design Art Museum. (Providence; Jesse Metcalf Fund and Walter H. Kimball Fund). As you can see, in order to determine the position of the light source (the sun), one need only trace a line upwards from the tip of each shadow, through the heads of the players.

32

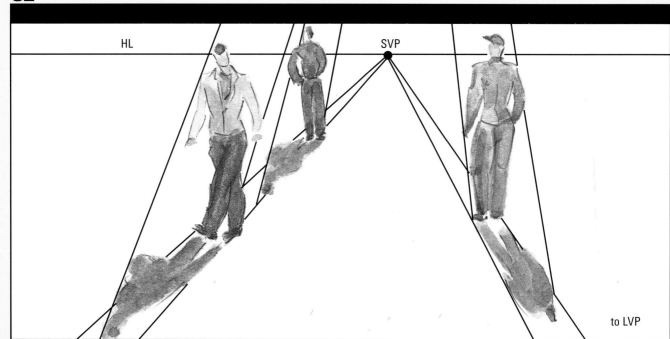

HL SVP

to LVP

33

Now we'll try to understand how shadows are drawn when the observer's position alters with respect to the sun. As with each element in a composition, projected shadows also relate to the horizon line and follow the laws of perspective. First let's look at how to draw shadows when the sun is high in the sky. If we mark a point on the horizon, the shadow's vanishing point (SVP) and then a point indicating light source vanishing point (LVP), we can trace diagonal lines from the light source which arrive at the figure practically parallel (fig. 32). The lines indicating the sun's rays will intersect with lines projected from the vanishing point, thus providing the reference points required to determine the direction and size of each shadow.

Fig. 32. When the sun is overhead and directly in front of us forms are backlit and the sun's rays are practically parallel when they fall onto the subject.

Fig. 33. When we paint a landscape with backlighting the shadows are projected towards the spectator. Artist: Charles Burchfield, *Frozen light*, Whitney Museum of American Art, New York.

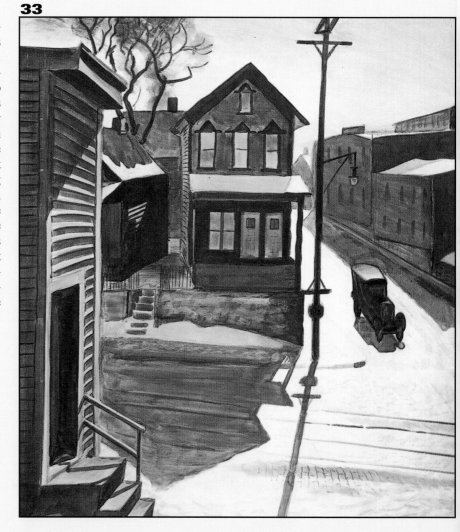

34

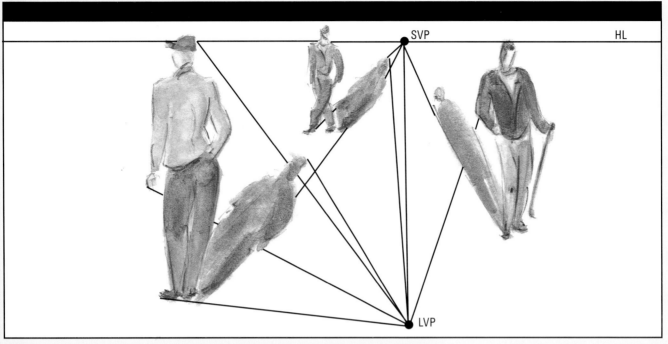

35

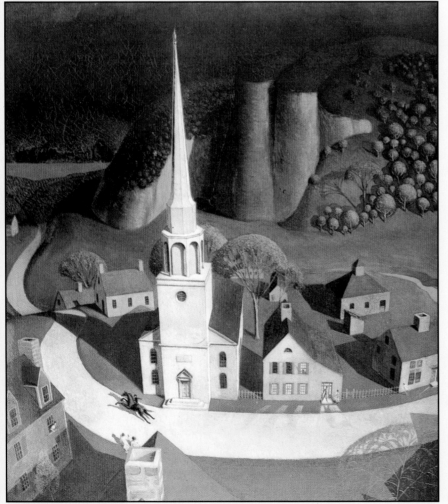

With a frontal light source i.e. when the sun is at the observer's back, the direction of the shadows is reversed. As you can see, in this case the shadows stretch away from the observer, in contrast to the previous example (fig. 34). With this light source the vanishing point is still situated on the horizon. However the second vanishing point has shifted and is now situated below the horizon line on a level with the ground. In any case, bear in mind that it is not advisable to paint with the sun at your back as most of the shadows remain hidden behind the objects casting them.

Fig. 34. When the sun, which is behind us, lights objects straight on, the vanishing point remains the same, however the second vanishing point is far below the horizon line.

Fig. 35. In any landscape lit from the front, shadows fall away from the viewpoint of the observer. Artist: Paul Revere, *Grant's Wood*, Metropolitan Museum of Art, New York.

Light from an artificial source can travel in parallel rays, similar to natural light, but, it can also radiate from a point (fig. 36), which causes more distorted shadows than those of natural light. The characteristics of artificial light are that it is sharp and bright when objects are close up, and casts more diffuse light on objects situated further away. Hence, the shadow's vanishing point is neither on the horizon, nor on the surface of the ground below the LS light source (fig. 39,

opposite page).
If we want to establish the length and direction of shadows, which in this instance light the image in figure 40 on the opposite page, we go about it in the same way that we did with natural light. It would be sufficient to trace just a few of the light rays originating from the LS, which cut past the edges of the object, and from the VP we can plot the other straight lines which reveal the direction of the shadows.

36

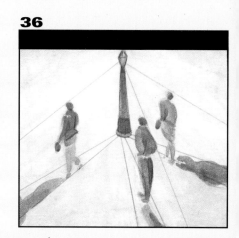

37

38

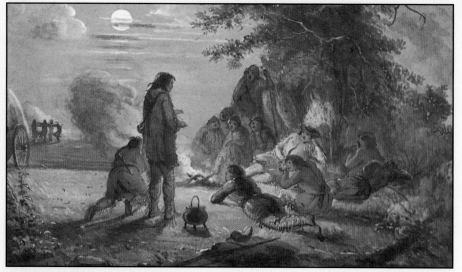

Fig. 36. Study the diagram of the lamp post, here you see an example of light radiating from a point.

Fig. 37. When a lightbulb lights a room the LS is the lamp itself while the VP is directly below. Once we locate these two points, it is simple to figure out where the shadows fall.

Fig. 38. Here is an example of light radiating from a point in a watercolor by Alfred Jacob Miller: *Hunters resting on a journey*. British Museum, London.

You will find the following exercises very helpful.

First, draw the shadow cast by a cube placed in an interior lit by artificial light. Start by drawing the cube and continue by marking where the rays LS make contact with the cube and the vanishing point VP to figure out the shape and length of the shadow. Remember that the method never varies, so you shouldn't have any trouble drawing the shadows of a sphere (fig. 41), a rectangle, a cylinder, a pyramid etc. Also try interrupting the shadow projected by the object with a wall or screen (fig. 40), and see how the shadow is projected upwards. Here, the height of the shadow is indicated by the lines traced through the top of the rectangle. This method can also be used when drawing irregulary shaped objects.

Finally, try drawing the image in figure 41 (a wall casting shadow over a rectangular beam lying on the floor), you will see how shadow responds when it falls across a three dimensional object.

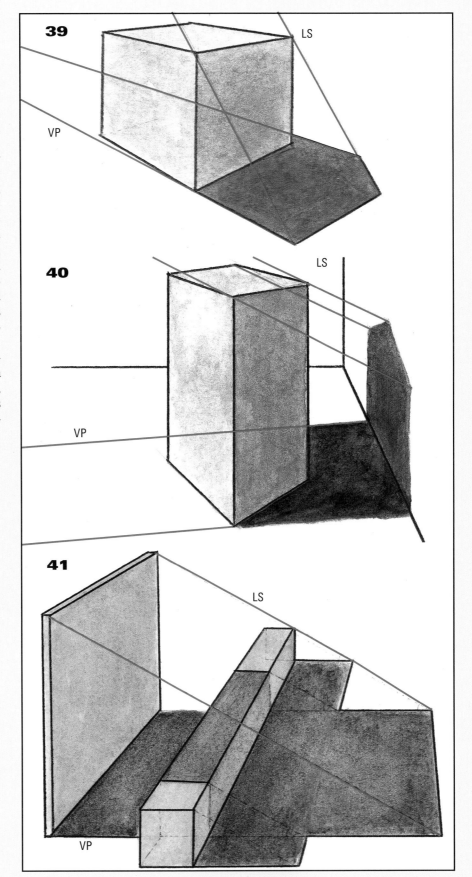

Fig. 39. Plotting the shadow of this cube is straightforward when you add the two points of reference and apply the rules covered in the last couple of pages.

Fig. 40. When the object casts a shadow over a flat surface, in this case an adjacent wall, the shadow can be plotted by lines projected from the LS.

Fig. 41. If you bear in mind that the line of shadow over a vertical wall is also vertical, it is easy to draw the shadow cast across a rectangular beam lying on the floor.

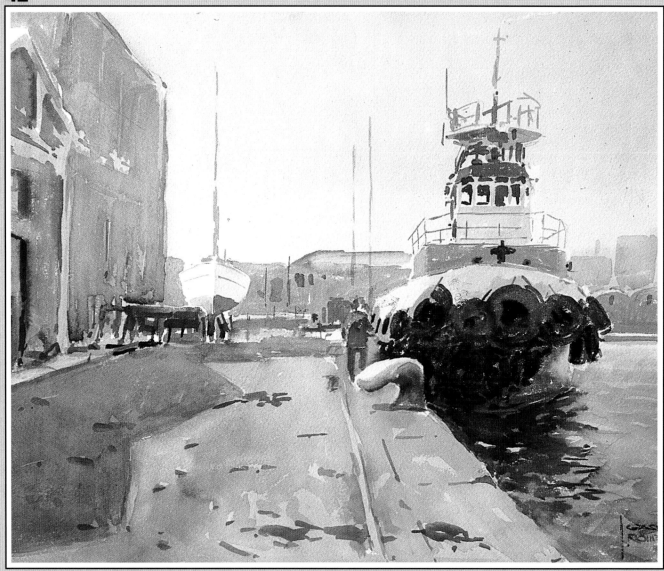

Fig. 42. Gaspar Romero. *The port*. Artist's private collection. In this water-
color, you can see how the artist has chosen to fade out the background
buildings; by doing this he has managed to create a sense of depth. See page
34 of this chapter for further methods of creating sense of depth.

LANDSCAPE TECHNIQUES

There are a vast variety of art techniques employed in painting landscapes watercolors. By looking at the work of artists of the past, students can learn from the infinite variety of techniques this medium has to offer.
In this chapter we will discuss basic considerations to bear in mind before embarking on the creation of a landscape painting. We start by taking a look at history's famous landscape artists, discuss how to choose your subject, and finally study a number of aspects relating to the correct use of color and interpretation of a landscape scene.

The First Landscape Artists: Dürer and the Dutch School

43

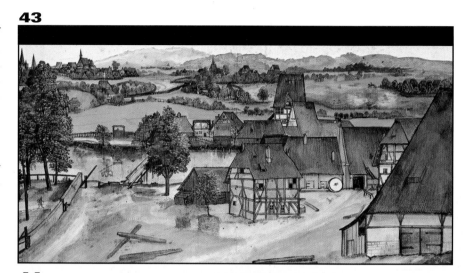

Albrecht Dürer is considered one of the most significant artistic figures in the European Renaissance. Son of a Goldsmith, he was born in 1471 in Nuremburg and left a legacy which has survived in the form of letters, written theories and meticulously worked watercolors. He painted 86 watercolors, 30 of which were landscapes; but, in spite of the delicacy of the work in these watercolors, Dürer considered his landscapes as nothing more than modest studies which "I could not honestly sell for money". The watercolors of his travels to Italy have survived to this day and are a vivid example of his dedication to the study of landscape (fig. 43).

While in Germany, some artists, including Dürer, continued to paint religious and mythical subjects. In Holland the themes were more profane: group portraits, still lifes, household scenes and landscapes. The reason for this development was the prevalence of Protestantism which forbade the creation of sacred images, favoring landscape as a principle theme of art.

Of the artists of this period, the following stand out:

Salomon van Ruysdael(1600-1670). Painter of realist landscapes, his notable early work was influenced by the subject matter and monochromatic palette of his friend and fellow landscape painter, **Jan van Goyen** (fig. 44).

Jacob van Ruysdael (1628/9-1682), nephew of Salomon. In keeping with other Dutch work, van Ruysdael's landscapes had low horizons and expanses of sky dense with dramatic cloud formations. He was able to build up ranges of monochromatic color creating an intense and luminous image. His work is characterized by his response to the way that atmospheric effects transformed the landscape. He would use the effects of powerful contrasts between light and shadow, such as beams of light suddenly breaking through in heavy cloud-filled skies (fig. 45).

44

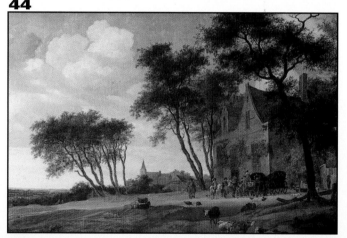

45

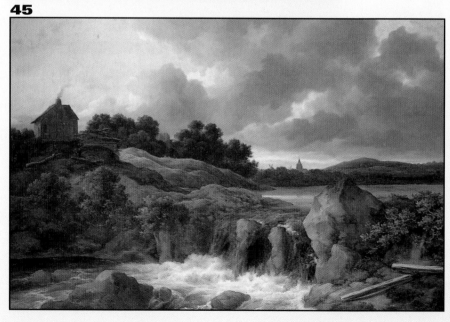

46

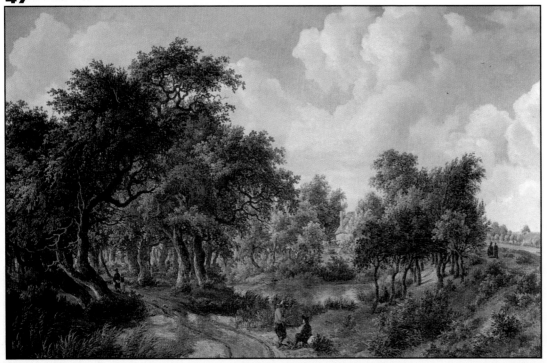

47

Fig. 43. One of the watercolors painted by Dürer during his journey through the Alps: *Trefilería*, Staatliche Museen, Preussischer Kutturbesitz, Albertina.

Fig. 44.*The heights,* by Salomon van Ruysdael. National Gallery of Ireland.

Fig. 45. *The waterfall*, by Jacob van Ruysdael. The Wallace collection, London.

Fig. 46. *Landscape with a stone bridge*. Rembrandt van Rijn. Rijksmuseum, Amsterdam.

Fig. 47. *Woodland scene*, by Meindert Hobbema. Wallace collection, London.

Rembrandt van Rijn (1606-1669). As a result of Rembrandt's outstanding ability as a portrait and figure painter, his landscapes are relatively scarce although their quality equals that of his other work when it comes to craftsmanship. His works include rustic scenes which often feature mysterious ruins lit by a diffused light which emanates from oppressive, stormy skies. Rembrandt would concentrate light on one area of the scene, focusing it on small details, leaving much of the composition in the half shadow of chiaroscuro, a use of contrast also adopted in his figure sketches. No other Dutch artist bestowed such depth and drama on their landscape paintings (fig. 46).

Meindert Hobbema (1638-1709). Another of the famous painters on par with the artists mentioned here. He was a pupil of Ruysdael and his early work is clearly influenced by him, although his best works appeared later, from 1660 onwards. These are large format works which recreate the changing effects of light on landscapes. Despite the similarity of his works to his master's, Hobbema painted sunnier, more cheerful scenes and avoided the sensation of silence and solitude that pervades Ruysdael's work (fig. 47).

Turner and the British School

By the time he was seventeen, William Turner (1775-1851) had begun to explore beyond London. He adopted the practice of drawing sketches *in situ* and then, in the studio, he transformed these into fully worked watercolors. This pattern of study heightened his capacity to paint from memory, developing and inventing shapes and colors and incorporating moving figures into scenes based on the simple sketches made from nature. Turner was the figurehead of a group of talented English watercolorists. The group included **Girtin, Cotman, Varley, Cox, De Wint**, etc., who were investigating ways of representing landscape in watercolor. However, despite this link with other artists of the period, Turner broke away from the contemporary style used for painting ruins and topographical studies; works whose principal merits were the rules of perspective,

and the achievement of truthful parity between the subject and its image. Although Turner's works represented recognizable places, he transformed them, by means of soft layers of pastel tones into atmospheric studies (fig. 48). Turner's freedom of style exasperated the critics who considered his work "unrefined, vulgar and chaotic". Fortunately, time has altered these views.

Following the tone-based phase of the last few centuries, the eighteenth century saw a swing towards watercolor works wich placed a greater emphasis on color. The work may have been more precise in some respects but there was no longer the need to show subjects in such realistic detail. In a similar vein to Turner, Thomas Girtin (1775-1802) developed a very original more interpretative approach to nature in which he altered the appearance of the subjects he

represented. He also developed an interest in atmospheric effects. As with many of the principal British artists of this era, Girtin mainly sought his inspiration from ruins and landscapes in Northern England and Wales. **John Sell Cotman** (1782-1842), and **John Varley** (1778-1842) also went to Wales in search of inspiration. Cotmans's work is characterized by the inclusion of geometrical elements (railway bridges, aqueducts, factories, hallmarks of the Industrial Revolution), contrasting the products of Industrialization with elements of Nature (fig. 51, following page). Varley's watercolours are characterized by a simplification of style and pureness of color, comparable to the work of **Claude Lorrain**, an artist much admired by this school of British artists (fig. 49, following page).

48

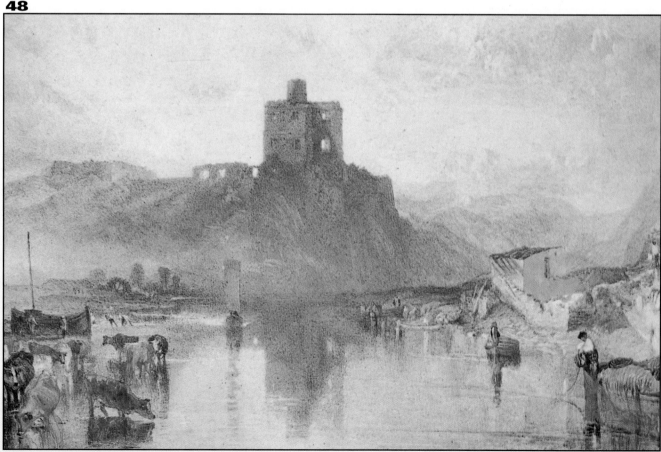

Fig. 48 (facing page). *Norham Castle*, William Turner. British Museum, London. Turner tended to paint landscapes at dusk because of the range of colors generally prevalent at this time of day.

Fig. 49. *Snowdon*, John Varley (unfinished watercolor). Victoria and Albert Museum, London. This work is characterized by its simplicity and pure colors.

49

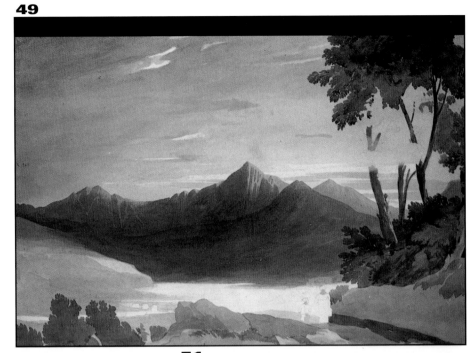

50

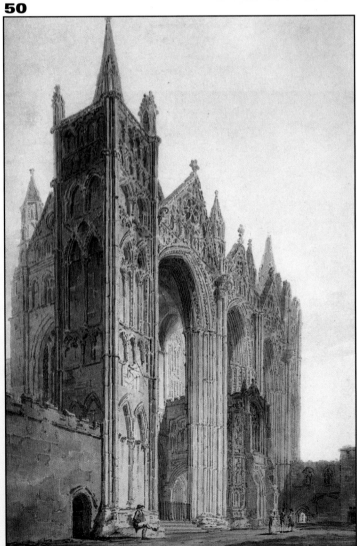

51

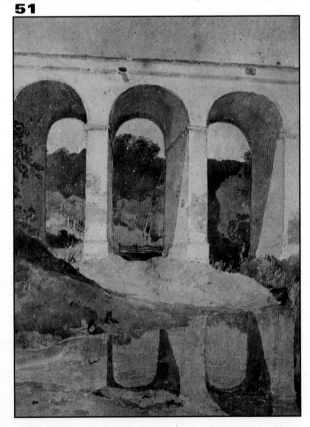

Fig. 50. *Peterborough Cathedral, Eastern elevation*. Thomas Girtin. Courtauld Institute, London.

Fig. 51. *The aqueduct at Chirk*. John Sell Cotman, Victoria and Albert Museum, London. In Cotman's work, manmade elements are harmoniously set amongst nature.

Impressionist Landscapes

Turner, with his own techniques of applying paint and his studies taken *alla prima* (from life), was seen as a predecessor of Impressionism. The reason for this is that, until the birth of Impressionism artists were accustomed, with rare exception, to painting in a subdued range of colors dominated by burnt sienna, dun brown and half tones. They painted with mannered, academic style, opposed to spontaneity.

Degas said in respect to this: *"It is all well and good to copy what you see before you, but that which you only see in your mind's eye is far superior..."*.

Impressionists painted *à plein air* (outdoors), which meant that they had to paint with a portable easel, on small or medium-sized canvases, completing their work in a short space of time

due to the fact that the direction and quality of light would alter constantly. The Impressionists left off mixing colors on the palette beforehand, they applied paint directly, reducing the range of colors to include only pure unmixed colors. The Impressionist vision concentrated on the visual effects of light and the sensations it created. In order to represent the play of light on objects, the contours of shapes would dissolve, the shapes themselves being made up of areas of vibrant color, produced by what we know as *optical fusion*. This sudden interest in light was due to the new optical discoveries of Chevreul, who established the concept of light's division into pure colors (of the rainbow). Impressionists were fascinated by these developments.

As Ruranty rightly said, *"His disco-*

very consists precisely in having recognized that natural light bleaches tones, that the sunlight reflected by objects tends, because of its brightness to break up within this luminous unity which is light".

The most significant figures in the Impressionist movement were **Monet, Pissarro, Renoir, Degas, Cezanne, Boudin** and **Sisley**. There were also less-known painters.

Fig. 52. *Industrial scene on the outskirts of Paris*, Vincent van Gogh, Stedefijk Museum, Amsterdam. In 1887 Van Gogh's watercolors showed the rich chromatic variation in common use amongst Impressionists as well as his inherent graphic skill. The deserted foreground is contrasted with a bustling background, a device often used by the artist.

52

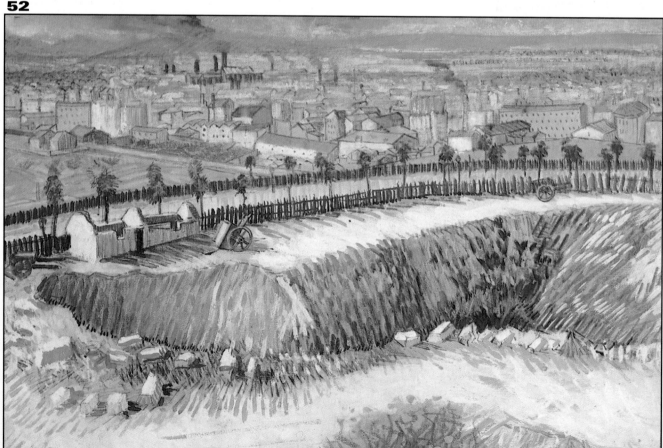

53 **54**

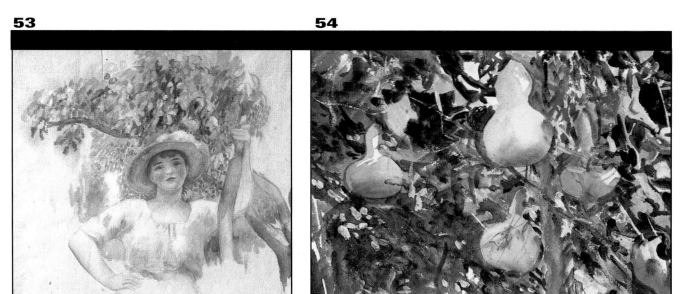

55

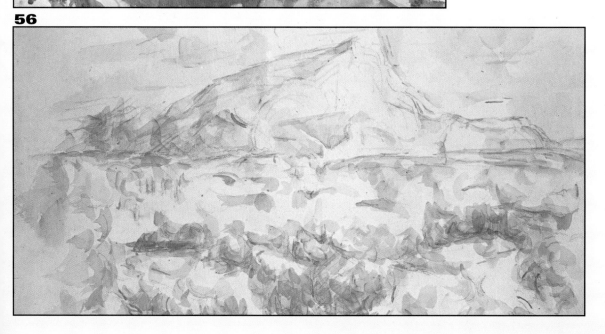

Fig. 53. *The flower girl*, Auguste Renoir, The Louvre, Paris.

Fig. 54. *Gourds*, John Singer Sargent, Brooklyn Museum, New York.

Fig. 55. *Figure by a lake*, John Singer Sargent, Metropolitan Museum of Art, New York.

Fig. 56. *View of Mont Sainte-Victoire*, Paul Cézanne, Tate Gallery, London.

56

Picasso's Landscapes

If we study the development of Pablo Picasso, one of the most important artists of this century, his series of landscapes completed during 1895 and 1896 prove very interesting. This series was painted while staying in Barcelona and Malaga. The characteristic features of these landscapes are their all small format and spontaneous strokes.

During this brief period, Picasso's approach to landscapes evolved: early linear representations made way for vigorous, erratic brushstrokes. In other words, he sacrificed precision in order to accentuate aesthetics. Bearing this in mind, we can group together these works into a series of studies of Barcelona's roofs at night and the Malaga sierra studies. In both, the artist is concerned with the transformation of nature into art just as the Dutch school had been some centuries before. In these examples of oil on board, Picasso is preoccupied with reproducing the changing moods of the sky, the changing atmospheric effects and chromatic variations which depend upon particular light conditions.

In the same period, Picasso also completed a series of seascapes which came to represent an important part of his development: through them, he progressed in the study of form using subtle chromatic combinations which would later lead him to paint his first abstract works.

57

Fig. 57. *Handrail and water deposit on a roof, from a series of roofs* in Barcelona. Pablo Picasso, Picasso Museum, Barcelona.

Fig. 58. *Study of a mountainous landscape*, oil on canvas, Pablo Picasso. Picasso Museum, Barcelona.

58

59

60

Fig. 59. *Mountain landscape*, oil on board. Picasso Museum, Barcelona. In his oil on board studies of the Malaga sierra, you can see the artist's interest in the shifting effects of light on the landscape.

Fig. 60. *Seascape*, oil on board, Pablo Picasso, Picasso Museum, Barcelona. It was through these small exercises that Picasso developed his first abstract works.

Developing your Creativity

61

If possible you should get to see the original works of the Great Masters face to face, there must be a museum not far from your home. Visit museums and galleries, there is no substitute for the real thing. You can really appreciate the quality and direction of each brushstroke, the texture of a canvas and the craftsmanship. These visits will help you understand creative and technical skills. Unfortunately, there isn't always a museum close by, especially if you live outside a city. If that is the case, books with reproductions of artworks give you access to a huge amount of visual information, and it is relatively easy to get hold of books with good reproductions. This is an excellent way of building a solid foundation of knowledge and in terms of developing your own creativity, will take you way beyond mere technical exercises. As a rule, art books are expensive although more recently, collections of reasonably priced monographic books on

62

artists with quality illustrations have come onto the market. Art books are a sound investment and a valuable source of information for the keen amateur to have on hand.

Fig. 61. If you live in a city you probably have a selection of art museums nearby where you can see the original work of the Great Masters. Photo: National Gallery of Ireland.

Fig. 62. Visits to exhibitions will keep you up-to-date with the latest developments in the art world and will help you to understand the creative and technical skills of well-known artists.

Fig. 63. You should always have art books on hand. They are a vital reference resource for any student of art.

63

Landscape Composition

Plato and Euclid's theories on composition have already been discussed briefly in another book of this series called *Composition & interpretation*, but here we will apply these theories specifically to landscape. The art of landscape composition requires the combining of shapes and the organising of the variety of elements present in such a way as to create order and unity. A couple of indispensable guidelines are explained below:

– **Plato's Theory** can be summed up in one sentence: *"Find and represent variety within unity"*. Apart from the variety of shapes, their position and size, elements of a painting have to be organized in such a way that there are elements of variety that catch the onlooker's interest within the unity of the image.

– **The golden section theory**. This theory attempts to pinpoint the ideal focal point in a painting, in such a way that the subject is enhanced. To establish this point you simply have to multiply the height and width of the picture by 0.618. This will lead you to the golden section or ideal center of the image.

With this in mind, carry out a geometrically precise sketch to apply this theory of variety and unity. You can opt for the use of the classic compositions like the rectangle, square and oval. Alternatively there are compositions based on letter shapes such as L, C or Z. Check the images on the facing page for these compositions which have been used in well known paintings (figs. 66 to 69, following page).

64

65

Figs. 64 and 65. By dividing any space into unequal sections (as above) you can achieve an aesthetic and balanced result. There must be a ratio between the smallest section and the largest section equal to the ratio between the largest section and the whole. To calculate this, all you need do is multiply the height and the width of the picture by 0.618. This will give you the golden section or ideal focal point of your picture.

Remember that **composition is a framework** and try to structure your picture on a composition based on a straightforward geometric shape. If you follow this advice, you can be sure that your watercolor will appear well balanced.

However, as well as the norms and models just discussed, landscape composition also depends on three other factors which create *variety* within *unity*: contrasting colors, tones and textures. These factors help hold the attention of the viewer and create a more appealing composition.

66

67

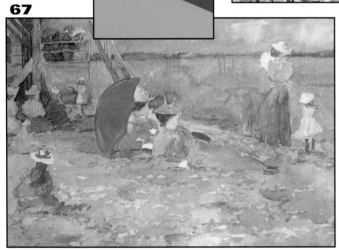

68

69

Figs. 66 to 69. If you look at these watercolors by famous artists you will appreciate how composition is one of the most important elements, in creating the unity which brings the picture together (fig. 66) *Municipal building*, John Marin, Philadelphia Museum of Art. (fig. 67) *The beach at Revere* Maurice Prendergast, Berry-Hill Galleries Inc., New York. (fig. 68) *Summer's day, New England*, Maurice Prendergast, Purchase Museum, Washington. (fig. 69) *Wooden pier at Escaut*, Johan-Barthold Jongkind, The Louvre, Paris.

Depth in Landscape Painting

When you draw or paint you are working in two dimensions; height and width. The third dimension, depth, has to be simulated. There are a number of ways to achieve this in a landscape, as we shall see:

1) **Creating depth through contrast and atmosphere** is one of the most common techniques used by landscape artists to create a sense of space and dimension. The sensation of distance can be expressed by recreating the atmospheric effects that affect the intervening space between the foreground and background. Atmospheric effects cause further objects to appear softer in color (fig. 70). *In any landscape the foreground will always be sharper and contains greater contrasts than the background. As you look further into the distance, the colors of objects fade towards gray. For this reason, the background of the picture should always be hazy and slightly unfocused.*

2) **The use of perspective** is of key importance when creating a feeling of depth. Perspective depends on a series of rules discussed earlier which help you to build the illusion of depth into a two dimensional plane (fig. 71).

3) **Creating depth by emphasizing the foreground.** The inclusion of an object in the foreground of the landscape —such as a group of trees, a fence or any object of easily recognizable dimensions— will create an illusion of depth. The observer draws a comparison between large foreground objects and the diminishing size of background objects, this creates an impression of distance (fig. 72).

Fig. 70. In *The port* (artist's private collection) by Gaspar Romero, the background appears hazy, and faded of color due to the atmospheric effects of distance.
Fig. 71. The use of perspective in landscape is particularly relevant in urban landscape, as you can see in this watercolor by Richard Parkes Bonnington, *The leaning towers of Bologna*, Wallace Collection, London.
Fig. 72. Merche Gaspar creates an impression of depth in this watercolor of *Galway* by including a fence in the foreground which acts as a reference point.

70

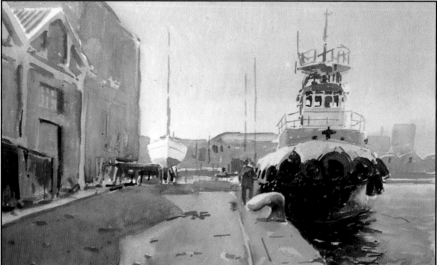

72

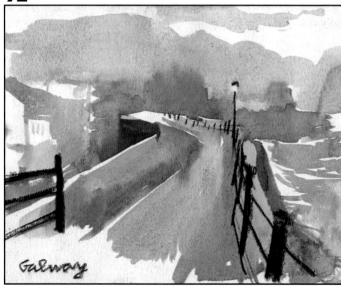

71

4) **Near and distant colors.** Copy the diagram shown below (fig. 73), by painting the lower border yellow, followed by orange, then red, and so on until you have completed the example. You will see how the warm colors (yellow and orange) "project" from the plane while the cool colors "recede" into the distance. Reds and greens occupy the middle ground. This helps us understand how use of the chromatic scale of colors creates an illusion of depth in a landscape (fig. 74).

5) **The *coulisse* effect.** *Coulisse* is a French word which refers to the wings of a theatre; the drop curtains and rece-ding layers of scenery used to create an impression of recession. This method of composition creates the impression of depth by superimposing successive planes in front of one another (fig. 75).

6) **Exaggerated contrasts.** To exaggerate the contrasts in a scene or to create contrast where none is present in the actual view, can emphasize outlines and mold shapes. Leonardo da Vinci said: *"The background against which the subject is set has to contrast it by falling into shadow where the subject is lit and being brighter behind the part of a subject in shadow"*. This is another way of recreating depth (fig. 76).

Fig. 73. This diagram illustrates the tendencies of colors in a chromatic scale, showing how an impression of depth is created.

Fig. 74. The principle explained in the diagram is put to use in a landscape by Carme Porta, it serves as an effective example of the use of near and distant colors.

Fig. 75. The *coulisse* effect. The bridge and the houses act as succession of superimposed planes in this watercolor by Carme Porta.

Fig. 76. Manel Plana often uses exaggerated contrast to create depth. *Pine trees*, artist's private collection.

73

74

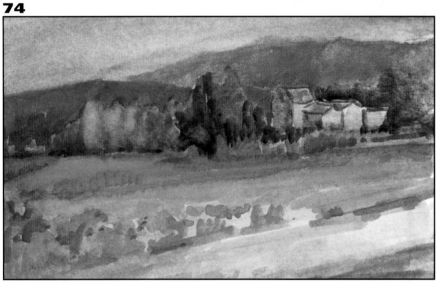

75

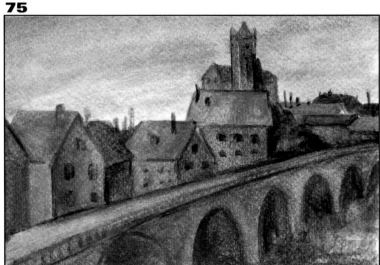

76

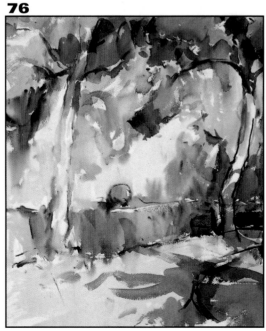

Learning from the Great Masters

As I mentioned earlier, seeing the original works of the Great Masters exhibited in museums and galleries is the best way of learning from them. It is vital in your development as an artist that you study work of other artists.

The French painter Monet always lived in towns on the river Seine because of his lifetime preoccupation with the representation of reflections on water. Many of his works stemmed from open-air studies of water which he then developed into paintings in his studio, where he worked on a number of canvases at the same time (figs.77 and 80). When he worked *à plein air* he would wear overalls and always had a parasol to protect him from the sun. The shade allowed him greater accuracy of judgement when recreating colors, because being dazzled causes you to paint with darker colors. In 1890 he started a series of works painted at particular times of day, studying different effects of light and shade. He painted the same subject a number of times, the only difference being the direction of the sun and light conditions. His now famous studies of Rouen Cathedral are an example of this (figs. 78 and 79).

Another popular theme favored by most of the Impressionists was a deserted path or road leading into a town, there are plenty of examples by Corot; and views of streets, squares and Paris boulevards, generally full of people, which were popular with Pissarro. Corot was a very skilled draughtsman. His early works were developed from open air sketches, which he transformed into large format works in the studio (fig. 82, following page). From 1865 onwards Corot painted directly from life, influenced by his Impressionist pupils, including Pissarro. Camille Pissarro, who as I've mentioned, preferred urban landscape, was interested in panoramic views, looking down over squares and streets. His work progressed through a number of different styles, among which pointillism was the most notable (fig. 83, following page). Van Gogh, who was shut away in a psychiatric hospital, painted many pictures of the view from his window (fig. 81).

77

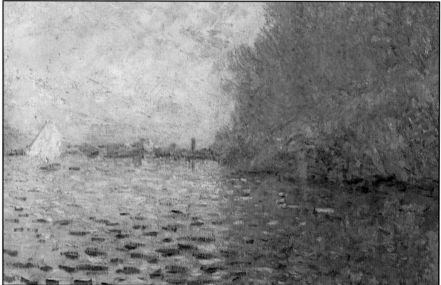

78

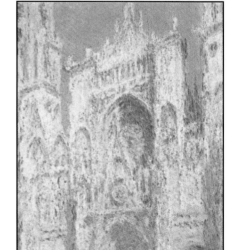

79

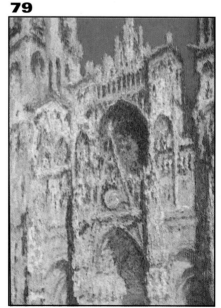

80

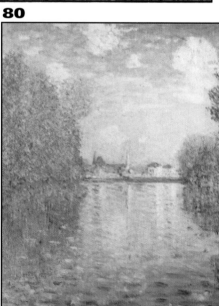

Fig. 77 (facing page). Claude Monet. *View of the river in autumn*. National Gallery of Ireland.

Figs. 78 and 79 (facing page). Claude Monet. *Rouen Cathedral in the morning sun* and *Rouen Cathedral at midday*. Metropolitan Museum of Art, Washington.

Fig. 80 (facing page). Claude Monet. *Autumn at Argenteuil*. Courtauld Institute, London.

81

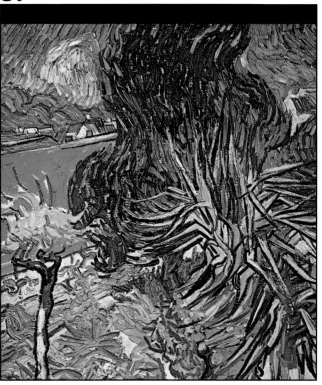

82

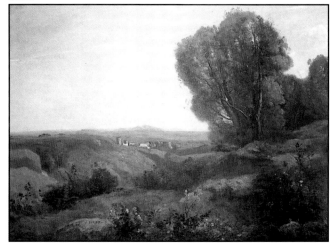

83

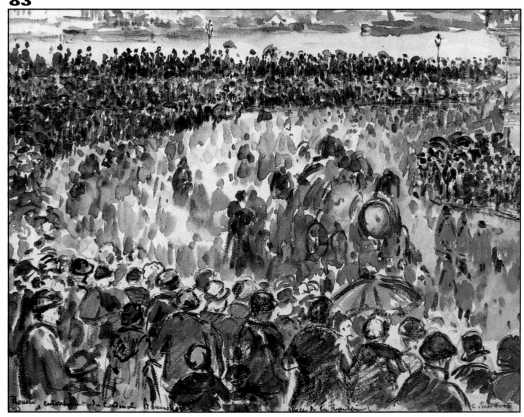

Fig. 81 Vincent van Gogh. *Doctor Gachet's Garden*. Musée d'Orsay, Paris.

Fig. 82 Jean-Baptiste Corot. *Memories of Roquemaure-dans-le-Gard*. National Gallery of Ireland.

Fig. 83 Camille Pissarro. *The funeral of Cardenal de Bonne-chose in Rouen*. Drawing archives, The Louvre, Paris. Painted with watercolor and black crayon.

Choosing a Subject

84

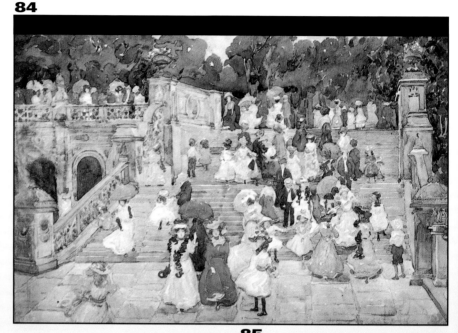

The life of the painter **Vincent Van Gogh** is fascinating as a result of his energetic painting and his madness. For him, a deserted garden, a solitary chair or his bedroom in Arles, where he was shut away, were suitable subjects to paint. In the same vein, another French artist, Paul Cézanne, wrote to his son about choosing a subject: *"The choices are endless; the same subject seen from another angle presents me with such a different impression that I could be working and painting for months without moving from the same spot, shuffling a little this way, a little that way"*.

In search of a subject to paint, the famous American watercolorist **John Singer Sargent** (1856-1925) organized an excursion along the Thames in 1885. He invited a group of friends and painters, including the poet Edmund Gosse, who recalls how the painter set about choosing a subject: *"He took along a huge easel, he would walk along for a while in the open air and then suddenly plant himself in a seemingly random place, behind a granary, on the other side of a wall, in the middle of a field..., the idea being to reproduce whatever he*

saw there".

Sargent certainly seemed to choose his subjects with a certain degree of randomness. He chose apparently unremarkable themes such as a river, portraits, views of mountains and sailing boats. However, he had evidently been drawn to the subject *"he had already seen the theme, imagined the composition and interpreted the picture"*.

85

86

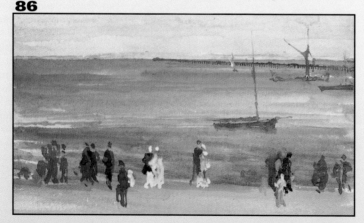

87

Fig. 84. Maurice Prendergast. *Central Park*. Art Institute of Chicago. A fascinating street scene bustling with figures.

Figs. 85 and 87. *Snowscape*. Ester Llaudet, artist's private collection (fig. 85) and *Polar landscape*. Edward Wilson, Scott Polar Research Institute, Cambridge (fig. 87). Snow scenes are also a popular subject; their

peculiarity is that they must be painted with a limited range of colors, while recreating the real colors of the scene.

Fig. 86. James Abbott McNeill Whistler. *Southend Pier*. Freer Gallery of Art, Smithsonian Institution. Artists drew much inspiration from the sea, an uncomplicated and beautiful subject, as can be seen in this lovely seascape.

88

89

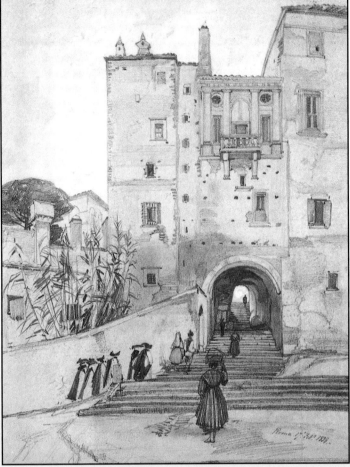

Having seen the way that famous watercolorists approach their work we can now deduce that the choice of subject depends on three simple factors:

1) **observation**
2) **composition**
3) **interpretation**

These must be achieved simultaneously since when an artist studies a subject, he must consider format, the most suitable light conditions, the most advantageous view point, structure and color scheme. The artist sees and analyzes the composition, at the same time imagining what he will leave out, what he wants to highlight, the dominant color, the contrasts to be accentuated etc. For this reason the Impressionists showed a preference for painting landscapes by lakes, rivers, the sea; rocky landscapes, snow scenes, woodland scenes, cityscapes, the edges of towns, orchards, fields, gardens and seascapes.

We can therefore conclude the following: coming across a subject to paint is relatively easy; the greatest challenge is to use your imagination so that the viewer finds the work pleasing and interesting.

90

Fig. 88 Samuel Palmer, *In the garden*, Shoreham. Victoria and Albert Museum. During the Impressionist period, gardens became one of the most popular subjects studied by the artists of the time.

Fig. 89 Edward Lear. *Flight of steps at San Pedro, Vincoli*. Tate Gallery, London. An entrance to a town is always an interesting subject because the perspective creates an eye-catching composition.

Fig. 90. Rudolf von Alt. *Caves at Tivoli*. Graphische Sammlung Albertina, Vienna. Rocky landscapes with caves and an abundance of greenery are popular subjects, particularly among British artists.

Painting Landscape Sketches

91

Landscape sketching is a good daily exercise for the hand. It is the best way to understand the different elements of which a subject is made up, synthesizing forms by recreating them in two dimensions. Most importantly this practice will help co-ordinate the hand and the mind, building up your drawing capacities.

Through studies and sketches you are attempting to note down fleeting observations and to capture spontaneity, imagination and originality, capturing the effect of the light, a certain color range, etc. in just a few strokes. Sketches have various basic functions: watercolor painting is a process of discovery, you are looking for aesthetic and eye-catching images, interpreting the elements of the scene in a comprehensible way through close analytical study of each element.

The best way to practice sketching and, as a result the best way to approach the technique of representing reality is by doing a series of sketches of the same subject, looking at the subject from a variety of different angles, altering the viewpoint and the format, and painting the subject at different times of day in order to study the various color harmonies. You have to draw the same subject many times before you get the results you want. Having reached this point, a piece of advice: however many sketches you make, don't believe that you have resolved the final work. The definitive painting is of great importance and when you are finally faced with it, a new set of problems will need to be resolved. To paint a picture from a sketch remembes that one slight error in the sketch will develop into a considerable problem in the painting. For this reason, the significance of making sketches is to study and learn, the resulting sketches are not, in themselves, finished paintings.

92

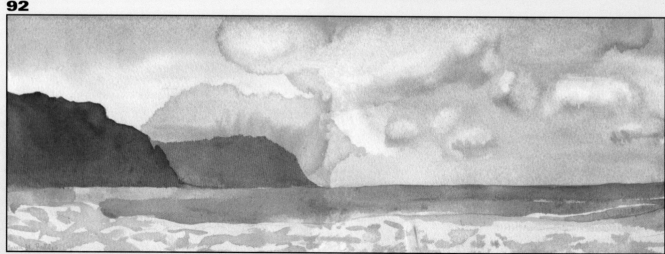

93

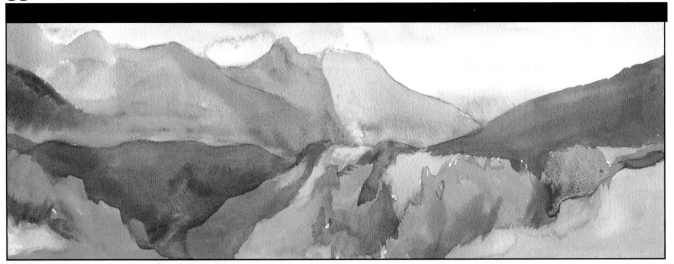

94

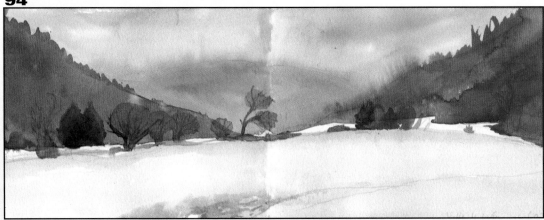

So, before embarking on a painting, paint various sketches, which serve to study the different possibilities of the subject. To sum up this chapter, I include the advice that Maurice Denis gave to the painter Helmut Ruheman: *"Before beginning a painting, make a small, rapid sketch of the composition and color scheme and don't be tempted to deviate from your initial impressions for anything in the world".*

Figs. 91 to 95 (figs. 91 and 92 on the facing page). Sketches and studies from Merche Gaspar's notebook. She always carries a sketch book and a little watercolor paintbox with her so that she can paint whenever she has the opportunity. It is usually landscape that catches her attention. She has taken subjects from many of her notebook sketches and transformed them into paintings.

95

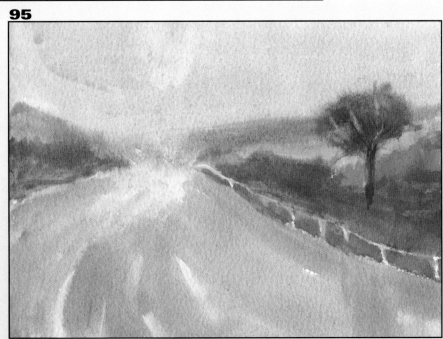

Color Blending

96

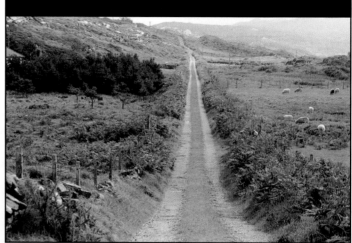

Color harmonization simply means to paint a picture with a tendency towards a particular color range. Harmony is the result of an understanding and use of particular color ranges. The clearest example of this is when you view a landscape at sunset, no matter what colors the landscape is made up of they will all be bathed with a pinkish hue as the sunset approaches. As night is falling the color range is likely to be warm; dominated by yellows, ochres, siennas etc. With the same amount of light, but first thing on a winter's morning, with a layer of mist hanging over the landscape, cool colors dominate, namely blues and greens. On an overcast, rainy day all colors tend towards gray, the range including grays, browns and dull colors. The artist must carefully consider the color range and may even need to accentuate it to achieve a better harmonization of color. So, we must consider how to adapt our palette to each range of colors which varies greatly from subject to subject. Consider these guidelines below:

1) **Identify the predominant colors of the subject.**
2) **Decide upon a suitable range of colors for the subject.**
3) **Accentuate certain colors to maximize expressiveness.**

Now look at the three examples, each painted with a different color range to best express the landscape.

97

98

99

Figs. 96 to 99. These landscapes were photographed at different times of day. You can see that they vary greatly; and in each case nature presents us with a certain range of colors.

Warm color range (fig. 100). This range is dominated by reds and closely related colors, it is red that gives the strongest impression of warmth. Despite the dominant warmth of color here, other colors can be included within the range such as green, yellow, orange, carmine and purple. It doesn't matter if there are hints of cool colors and transitional colors like violet or lime green included within a predominantly warm range.

Cool color range (fig. 101). A range focused on blues and closely related colors. the range may extend from lime green through cyan to ultramarine blue and dark blue to violet. As in the previous example, warm colors such as yellow, sienna or red are not altogether excluded.

Pale colors (fig. 102). This color range is preferred by many artists due to its chromatic subtlety. It is produced by mixing complimentary colors in different proportions and adding white (which, in the case of watercolor, is the white of the paper).The result is a range of colors close to gray which can be warm, cool or neutral.

100

101

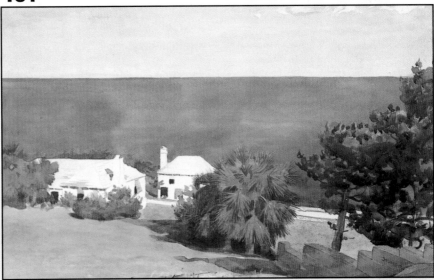

102

Figs. 100 to 102. Warm color range: *From Vallvidrera*, Manel Plana, Artist's private collection (fig.100). Cool color range: *Bermuda coast*, Winslow Homer, Brooklyn Museum (fig.101). Pale color range: *Landscape at dusk*, Auguste Ravier, Drawing Archives, The Louvre, Paris (fig. 102).

Colorist and Tonalist Approaches to Landscape

The tonalists give forms volume by the use of tonal values, shaping objects with light and shade, relying on the use of shadows cast by objects to define their volume. The word tonal suggests the representation of the gradation of different tones of varying intensity. Painters such as Corot, Courbet, Nonell and Dalí fall into this category.

Colorists create form through flat colors, without the use of shadows, arguing that *"The use of color alone can create variety among and division between objects and can describe the form of objects"*. Colorists generally prefer their subject to be lit from the front or with a diffuse light, without shadows, and they give volume to the subject by using blocks of color (fig. 106, following page). Van Gogh and Matisse are colorist painters.

In order to paint in a tonalist style, the subject must be painted through the use of light and shadow contrast. The subject can be lit from any angle, the front, side, from above or from behind, however, the optimum lighting for a colorist is from the front as

this option reduces the amount of shadow to a minimum.

There are those who see the colorist methods as contemporary and claim that the tonalist style is more classical, having been employed by artists up until the last century (fig. 105 following page).

However, the statement holds that *"there are no good or bad styles, simply a good or bad way of employing those styles"*.

Fig. 103. In this watercolor by John Marin, *Effects produced on the river flowing through Paris*, Philadelphia Museum of Art, is evidence of the artist's marked commitment to colorist style. Many thick brushstrokes recreate the movement and reflection of the water's surface which is altered by the barge's passage along the river.

Fig. 104. In contrast, Thomas Moran in his work *The cliffs of the river Virgin*, The Smithonian Institution's, National Museum of Design, New York, is a typical example of the tonalist style. You can see the successive changes in the intensity of light in the range of tones used to shape the landscape.

103

104

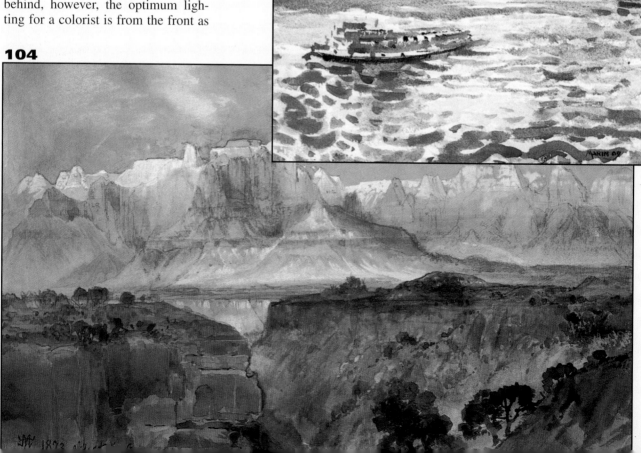

105

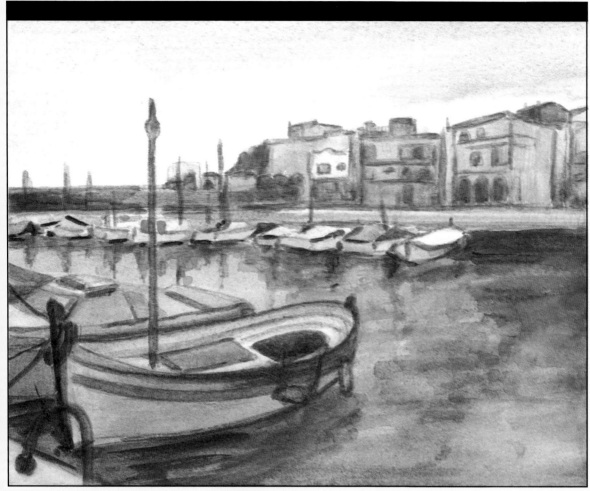

Figs. 105 and 106. Compare the two watercolors painted by Carme Porta, *Ports*, artist's private collection. The same subject has been painted in a tonalist style (fig. 105) and in a colorist style (fig. 106). In the former, the objects have been given volume by contrasting light and shade. In the latter, the objects in the scene are given volume through the use of colors, avoiding the use of light and shadow employed earlier.

106

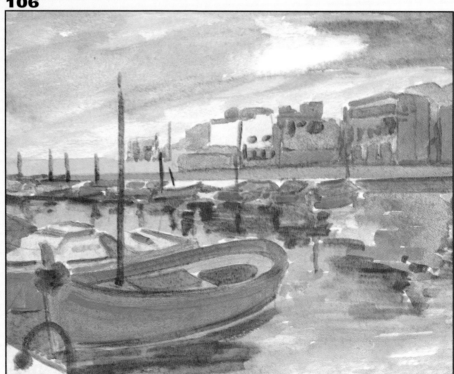

Synthesis and Interpretation in Landscape Painting

107

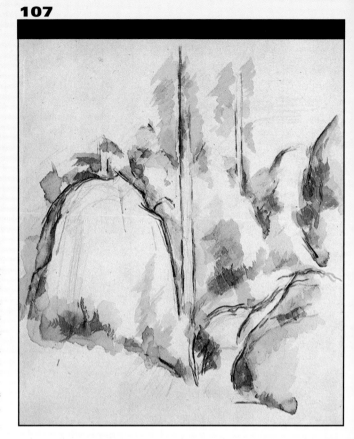

There are two approaches to painting: either you can set out with the intention of mirroring reality just as it appears, echoing the shapes and colors of the subject, or you can interpret the subject in a subjective way. There is no incorrect approach, but the second option allows the artist to reinterpret the subject, allowing their impressions and emotions to remould the scene or object that they are representing. Van Gogh's images of landscapes are interpreted in this way; he eliminated detail because he was concerned with capturing the essence, of synthesizing what he saw: *"Since I always work from life, I endeavour to capture only that which is essential, for this reason I fill each limited canvas space with equally simplified tones, which deliberately exaggerate the actual colors"*. It was this concept that the Impressionists embraced, allowing them to break away from the restrictions of producing a mirror image of the subject.

So, painting using this approach of "synthesis" means that while the painting is made up of fewer brushstrokes, the subject is still recognizable, allowing you to gauge the shapes and colors. Carme Porta's painted sketches illustrate this (figs. 109 to 112, following page). These images are achieved through the use of various dashes of color which suggest forms in perfect synthesis with the shape of the subject. Sketching is an excellent way of practicing this effect. Try to paint two, three or even more versions of the same subject keeping in mind that you are experimenting and putting the process of interpretation and synthesis into practice.

108

Fig. 107. Paul Cézanne. *Rocks at Château noir.* Musée Granet, Aix-en-Provence. The Impressionists discarded realism to develop an abbreviated style in wich a minimal number of lines express the essence of the scene.

Fig. 108. Paul Klee. *Saint-Germain near Tunis.* The Pompidou Centre, Paris. Expressionists such as Klee used synthesis in their interpretation of landscape.

As well as capturing the essence, the artist must endeavour to interpret the subject in their own way, even altering reality if necessary.

With this in mind, Cézanne commented: *"When painting from nature your objective is not to copy, but to express your own feelings. The painter needs two things: sight and mind, and he needs both to help him achieve this. [...]Sight, through physical vision; and mind, through logic and sensitivity.*

Your first step, as always, should be to study the subject at length to see if there are any ways of improving or altering any details of the composition. This is the point at which you will consider leaving out certain elements such as posts or fences, etc. You can change the composition, the contrasts in the foreground, the way that atmospheric effects alter the background and the color range. There are three verbs which sum up your approach to interpreting a landscape or still life:

- **exaggerate**
- **suppress**
- **omit**

Exaggerate, express, augment, intensify the contrasts present in the subject, colors (brightness and intensity) and the size of different elements of the composition.

Suppress, fade, soften, reduce the size of the trees, the width of a road the color of fields and mountains, the contrasts between foreground and middle ground, the volume of the clouds, etc.

Omit, eliminate, cover up, ignore, elements that are not in keeping with the scene; an asphalt road cutting across a field, a tractor or a lorry for example.

109

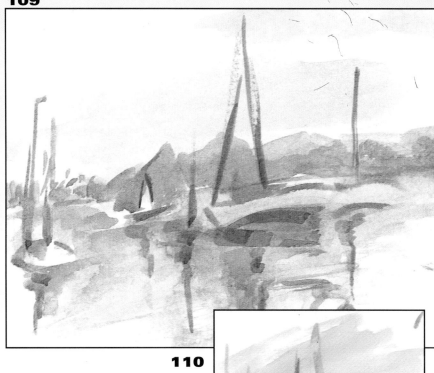

110

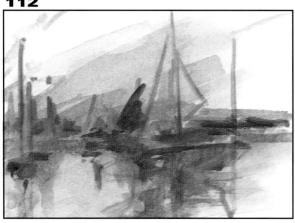

111

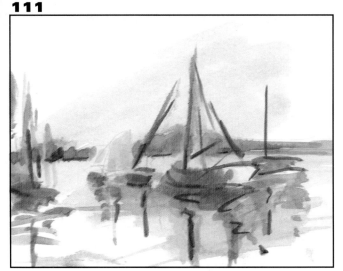

112

Figs. 109 a 112. Carme Porta. *Sketches of boats.* **Artist's own collection. Practice through sketching gives you the opportunity to improve on your interpretation and to synthesize the forms and colors of a landscape. For this reason, Carme Porta makes a number of studies first, to find the most suitable image on which to base her painting.**

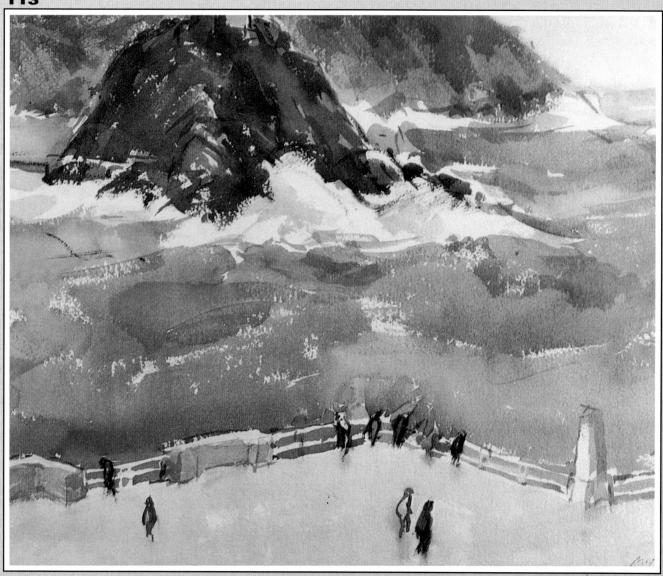

Fig. 113. Manel Plana. *The island of Santa Clara.* **Artist's private collection. When painting the sea, bear in mind that it is not blue, it reflects the color of the sky, which, in this case, explains the grayness of the sea due to the overcast sky. Painting seascapes is discussed on pages 60 to 65.**

FINER DETAILS OF WATERCOLOR LANDSCAPE

In order to paint landscapes you must be familiar with all the elements they are made up of, studying each in turn, as set out in the following chapter. We will analyze the changing aspects of the sky; types and shapes of clouds; color and texture of the ground; relief of rocks, reflections and transparency of the sea, how to paint foliage of trees and bushes, as well as a brief look at figures in landscape. We will discuss the differing characteristics of these elements with the help of clear graphic examples, written explanations and watercolor sketches. So, let's get started...

The Sky and Clouds

According to **John Constable**, the British artist who made countless studies of clouds and skies in watercolor, *"the sky is the most fundamental element, the source of light which presides over the entire landscape, and it is the most important plane of expression"*.

Likewise, **Alfred Sisley** also considered the sky of paramount importance to any landscape: *"The sky is not just a background wash, a bright abyss. The sky is brother of the plain and like the ground it consists of receding planes. I always begin with the sky"*.

Generally the sky determines the colors which are to dominate the painting and will define a range of colors, either warm, cool or pale depending on whether the sky is cloudy, clear or glowing at dusk. The

sky and the clouds give another dimension to nature, any hint of permanence vanishes, and the landscape responds to constantly changing veils of vapour or clouds as they travel across the sky, often filtering the direct sunlight.

Effective painting of clouds depends upon mastering how to paint washes, spontaneousness, crispness of finish, confidence in drawing, and planning the composition, leaving white spaces where necessary. This all falls within the technical process of resolution and synthesis. **Eugene Boudin**, a French artist who was considered one of the most important precursors to Impressionism made the perceptive statement that *"three brushstrokes made from life are worth more than two entire days work at the easel"*.

A keen student should bear the following points in mind when painting skies:

Firstly, a less experienced painter should never rely on improvization; in fact it is preferable to draw in the shape and position of clouds first. Secondly, before starting to paint, you should take a few moments to study the direction of the light, bearing in mind how passing clouds

Fig. 114. The great British Romantic painters were drawn towards the study of climatic changes visible in the sky, and they eagerly took on the subject including in their works an array of details and colors, as can be seen in this watercolor by Joseph John Cotman, *Scene on a river* (private collection).

114

115

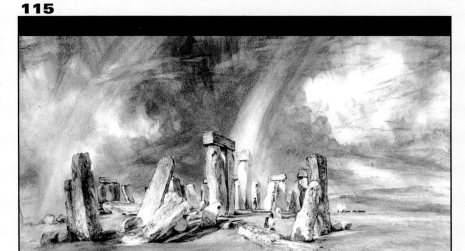

affect the light and, in turn, the resulting effect on the landscape. Having considered these basic premises, we will now look at how to paint cumulus clouds, stormy skies and clear skies, and how to give form to the unique substance of clouds.

116

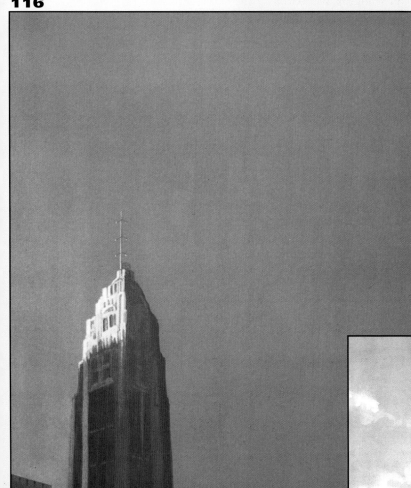

Fig. 115 The sky determines the colors of the landscape as if the sunlight were filtered by a colored veil and light falling onto the scene determines the predominant colors. Study this effect in a watercolour, *Stonehenge*, by John Constable (Victoria and Albert Museum, London).

Fig. 116 Painting skies doesn't always imply painting clouds; you must also know how to paint totally clear skies. This example is by John Button, *The Lincoln Tower*, artist's collection.

Fig. 117. Since the seventeenth century the sky became an increasingly prominent feature and started becoming the focal point of works. Sunsets are a popular subject amongst watercolorists, like this one painted by Arthur B. Davies in 1925: *View from the Port of Orleans*. The Brooklyn Museum.

117

Cumulus and White Clouds

Who has never laid on the grass looking up at the shapes that clouds make, visualizing animals, faces or objects? One of the most fascinating things about these masses of vapor that we call clouds is the infinite variety of shapes that they form. This explains why, throughout history, artists as outstanding as Constable, Ruysdael and Turner gave them such an important role in their works. Cumulus clouds appear solid, have volume and look most majestic in sunny skies as the sun gives depth to their characteristic shapes. The large white clouds present us with difficulties when trying to draw or shade them; their shape, the very subtle tonal variations, the shadows, reflected light and the effect of the contrast of the clouds against a blue sky. A white cloud in a deep blue sky will appear far whiter than a cloud in a paler blue sky. This is due to the contrast between colors:

A color is lighter or darker depending on the color which surrounds it.

This means that when clouds are white the rest of the paper cannot be left white but the clouds must be contrasted with a darker background. The first step when painting clouds is to make a pencil outline of their shapes. having drawn them, continue by painting the sky (usually blue) and leaving blank white spaces for the clouds. Next, outline the silhouette of the edge of the cloud with a brush and finish by adding the shadow tones.

Figs. 118 to 120. Look at these three cloud studies by Merche Gaspar: *Clouds*, artist's private collection. You can see clearly here how the cloud is given volume. Firts, the outline is silhouetted against the blue sky. The white of the paper is left on the top of the cloud where it is lit by the sun and the underneath is painted a soft grey with a tinge of red, brown, yellow or blue where it is in shadow. The cloud appears to take shape.

118

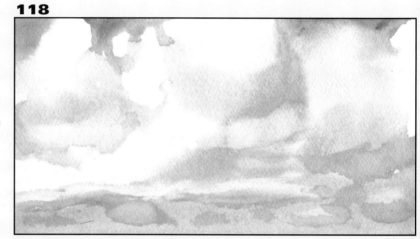

119

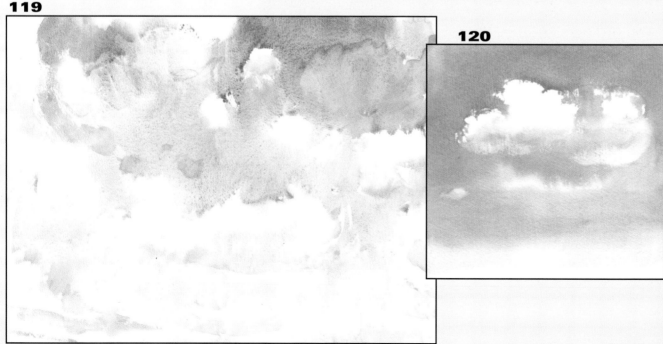

120

Stormy Skies

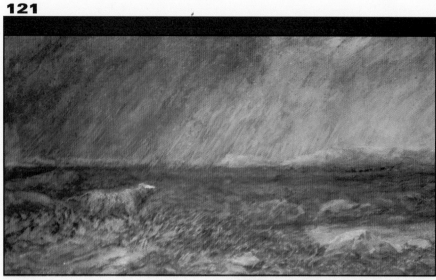

Stormy skies were the subject of many studies by Flemish and British painters: skies covered by huge dark clouds which darkened the lively colors of the landscape; violent masses of vapor which signalled the imminent onset of a storm, forewarning a catastrophe. Put this way it is not hard to imagine why stormy clouds were a popular theme among the Romantic painters who were so attracted to the awesome, violent power of nature. Tempestuous skies allowed the artist a free range with his imagination, to alter the landscape in expressive and beautiful ways. The artist expresses the feelings of his soul through nature, and reveals the passion he has discovered in it.

The violence and haste of the storm are expressed by lively brushstrokes, in such a descriptive way that the storm seems to move across the picture plane. This pictorial device stems from the fact that these types of clouds move at a great speed and must be painted in a hurry, because to paint them accurately you have to capture the image before it changes. For this reason, stormy skies aren't usually sketched with pencil first: paint must be applied directly over a wash, normally onto wet paper.

These washes take on a variety of forms originating from a combination of stratus and cumulus clouds with a tendency to darken the top of the painting towards gray and dark gray.

Fig. 121. *The challenge,* attributed to Cox (Victoria and Albert Museum) represents a storm. See how the ranks of vertical lines in the sky obscure the Welsh landscape.

Fig. 122. *Sea port during a passing storm.* J.M.W. Turner. British Museum, London. One of the great storm painters describes the passage of storm clouds over a British port.

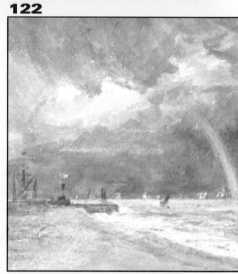

Fig. 123. In this image, *Tempest,* (artist's private collection), Merche Gaspar, the stormy clouds are painted with wet brush technique over a wet wash. The sky takes such precedence that only a sliver of land is visible along the bottom edge of the painting.

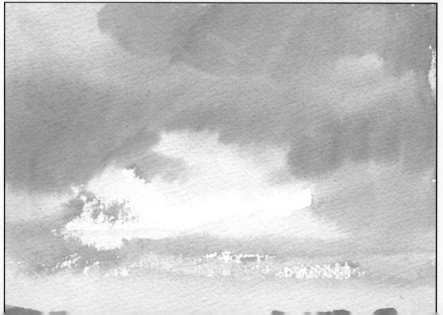

Clear Skies

As we have already discussed, the sky is often the largest and most important part of a landscape, and therefore when a watercolorist starts a painting his first concern will be to work on the sky, painting over some areas and leaving others to make contrasting white spaces. But, how do you paint a sky when there are no clouds?

First, you must be aware when you paint a clear sky that the color is usually slightly more intense at the top of the picture, where the blue has a tendency towards carmine or cadmium red with a hint more ultramarine, and may also include a dash of vermillion, and gently easing to a paler color in the lower half, approaching the horizon, where, occasionally it takes on a soft creamy yellow tint.

A clear sky should never be represented by fading the color perfectly evenly. You must create a vibration of light and color, avoiding uniformity at all costs. This is achieved by mixing tiny quantities of other blues or colors of subtly different hues which harmonize with one another, interrupting the uniformity.

124

125

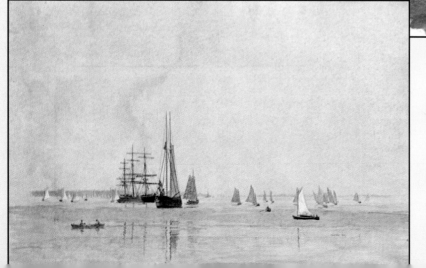

Fig. 124. Merche Gaspar, *Watercolor*. Artist's private collection. When you paint a clear sky remember that the color is most intense at the top, fading as it proceeds towards the horizon, where sometimes it may take on a soft creamy yellow tint.

Fig. 125. Thomas Eaking. *Going with the tide*. Private collection. In this painting the colors of the sky diminish through a chromatic range, unlike the change in tone of the blue sky in the other image. See how a subtle spectrum of colors is visible in the sky.

Chromatic Variation

You must have observed many times that the sky is not necessarily blue but tends to change color, offering a wide range of chromatic variety.

It can be rose pink, golden, soft yellow, orange, or even slightly green, depending on the time of day. This must be taken into consideration as the light conditions of certain meteorological states will affect the tone of the entire scene. This type of chromatic effect can be seen during spectacular light shows during sunset, when the light of dusk washes the landscape with an orange glow. The same effect over the sea highlights this effect to its maximum. Another dramatic effect occurs when the sun is hidden behind the horizon and the sky begins to deepen to violet as night sets in. Nowadays, through the use of readily available camera filters, the color of the sky can be altered to give it a rosy or orange glow. This practice is put to great effect in the world of advertising. If you are a photographer as well as a painter you will already be aware of this. These sorts of photos allow us new interpretations of a single subject, emphasizing or subtly varying the chromatic range. You should therefore not have any reservations about taking a camera with you when you go out to paint.

Fig. 126. Thomas Moran. *Universal Exhibition of Chicago*. The Brooklyn Museum, New York.

Fig. 127. David Cox. *Breakwaters at Calais*. Witworth Art Museum, Manchester University.

Fig. 128. Merche Gaspar. *Sunset*. Artist's private collection.

126

127

128

Earth and Rocks

129

As you will have observed, the color of soil varies greatly. The variety of tones and different colors seen in the fields, roads and mountains is determined by soil content, the distance from which you are observing, the time of year, weather conditions and the angle of the sun striking the ground. Despite these differences soil has some common properties which it helps to bear in mind.

The color of soil is dark in a recently ploughed field, as the clods of earth and undulations cast shadows which darken the color; the color of the earth will be lighter on barren wasteland (water darkens the color of soil), and even lighter on earth roads or paths. Dry, flattened earth, without undulations suggests a more even tone of color which reflects more light. Dominant colors created by shadows of turned earth are sienna, red and red carmine, while colors of roads and paths tend to contain more blue. The last factor to consider is distance, which can alter the color of the land giving it a bluer or grayer appearance as the land recedes further from the viewer. As you know, when we observe mountains in the background their color is softer and they take on a bluish purple color as a result of atmospheric effects over a long distance.

130

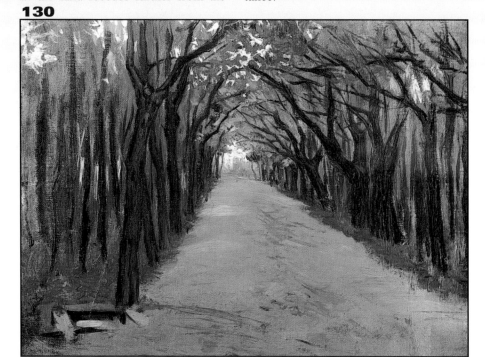

Fig. 129. Pablo Ruiz Picasso. *Mountainous landscape*. Picasso Museum, Barcelona. See how the artist has succeeded in recreating the irregularities of this landscape through the use of hints and variations of different colors which give the land shape and depth.

Fig. 130. Pablo Ruiz Picasso. *Road through trees*. Picasso Museum, Barcelona. The color of the earth is lighter on roads and paths, notice how the color of the path fades into the distance.

131

We will look at a practical example of how to paint soil. Merche Gaspar is going to paint the floor of a woodland scene: the earth is rich in subtle changes in light. It is uneven, littered with leaves, and spangled with light which filters through the leaves of the trees.

With very little sketching, the artist paints in the general tones of the scene using wet brush technique, in such a way that, from the onset the tones and some hints of color of each area are determined. As you can see, at this point the watercolor is a basic map of pale colors which already creates a sense of atmosphere, an impression of space and distance (fig. 131).

In the second phase, the artist takes a synthetic fiber paintbrush and masks the highlights with latex applied in patches on the ground, where illuminated spots have been cast by the rays of light penetrating the leaves.

The artist now continues to add color and shape to the vegetation and leaves, painting the areas in shadow with olive green and using light green, yellow and orange for the areas such as the branches in the foreground that are bathed in sunlight (fig. 132).

Having done this, the artist proceeds with the darker areas, burnt Sienna mixed with a little vermillion in the distance where the ground is in deep shade. The same color is mixed with turquoise and cobalt blue for the furthest areas of deep shade, in order to give shape to the ground and create recession while accentuating the variety of contrasting colors on the ground. After finishing with the earth in the foreground the artist moves on to consider and work on the shapes and colors of the tree foliage and to enrich the unworked areas (fig. 133).

Once the picture is finished she removes the latex with an eraser. Light areas beneath will be revealed, patches of vivid brightness which increase the contrasts between light and shade.

132

133

Figs. 131 to 133. Merche Gaspar's study of the floor of a woodland scene at various stages of development. Notice the number of different hints of color used in creating the ground and how they are put to good effect.

You should not be daunted by the irregular and often complex form of rocks. Instead, see their advantages; they allow you to break free from the restrictions of academic rules. Rocks can be categorized, generally, into various geometric forms; cubes or cones wich are more or less specific in shape which act as a guide for drawing their structure.

What better than practice when it comes to understanding the way rocks are shaped? You can see here various ways of tackling the shapes and colors of rock formations, painted by Gaspar Romero.

Figure 134. In any seascape you may have to paint rocks or cliffs partly submerged in the water. In these cases bear in mind that the level of the water creates a darker wet fringe where it makes contact with the half submerged rock.

Figure 135 is a study of a dolmen. The shape and color of the rock and its volume are represented by use of little patches of superimposed colors within the chromatic range of cool colors, using darker tones in the cavities and lower parts of the rock. This approach works well when there is not much relief on the rock surface and it has few ridges.

A good method of representing the relief of a rock can be seen in figure 136 which accentuates —through dramatic use of light and shade— the irregularities and ridges of the surface without losing the *chiaroscuro* and the hints of reflected light in the shaded parts.

134

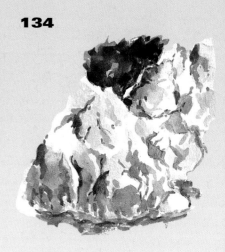

135

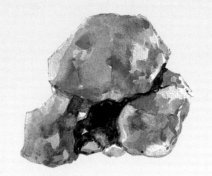

136

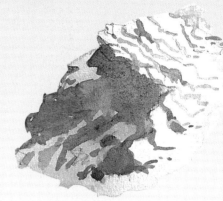

137

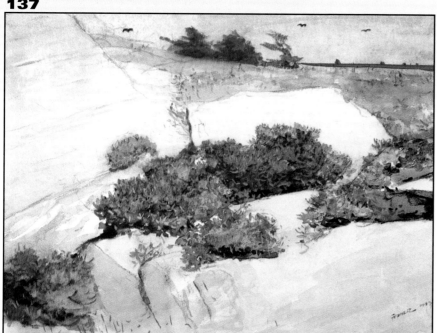

Figs. 134 to 136. Various ways of representing rocks by Gaspar Romero: one has been achieved by superimposing patches of color (fig. 135). Another through use of contrasting light and shade (fig. 136), and a third which is partly submerged in water (fig. 134).

Fig. 137. Rock formation in *Cliffs in Maine*, Winslow Homer. The Brooklyn Museum, New York.

Given that a cliff next to the sea is one of the best subjects when learning to paint rocks and to understand their peculiarities, let's look at Gaspar Romero's study and see how the shape, color and structure of the rocks of these Costa Brava cliffs are expressed through use of wetbrush technique.

Having made a faint pencil sketch, add a couple of uniform washes to give the subject its basic shape, using ochre for the lighter areas and a purplish tone for the fissures and shaded parts (fig.138). Then start adding details to the rock surface on the left and the little plants in the foreground, overlaying another wet layer of color onto the wash below with generous firm brushstrokes. It is better to work on the volume of the rocks little by little, moving from lighter to darker areas, working stroke by stroke, giving the rocks their characteristic irregular surface (fig. 139).

As you can see, each layer is made up of a series of brushstrokes in different directions, so that the layers are superimposed. Gaspar Romero works rapidly, and each wet brushstroke merges with the next to form an amalgam of tones and different hints of color.

He finishes off by painting the water with an irregular wash of ultramarine blue, leaving white spaces which represent the reflections and the foam created as the waves break against the rocks.

Finally, with a finer brush, he develops the foreground by adding darker touches to the vegetation. This is when details such as the cracks in the rocks should be added, he avoids going into too much detail however, as the scene would lose its freshness and spontaneity.

138

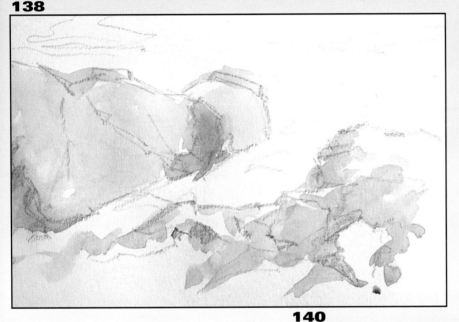

139

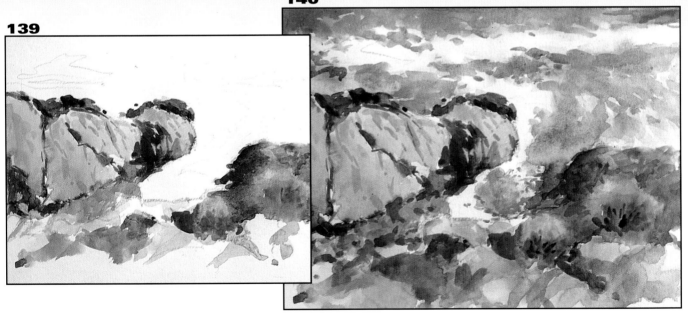

140

Figs. 138 to 140. Painting rocks is like a painting a puzzle constructed from different planes. Apply the brushstrokes paying close attention to the direction they are painted, as this will help to further define the volume of the rocks.

The Sea, Boats and Reflections

Since ancient times, man has been fascinated by the immensity, movement, color and changing moods of the sea. Over the centuries seascapes became one of the classic subject matters of art, closely linked with landscapes, both of which offer a great deal to the artist. When an art student paints the sea, the greatest problem they encounter is that the sea offers no visible structure and it is difficult to simulate depth and distance unless there are a few reference points such as boats, islands or cliffs. Here are a few points to consider when painting the sea:

1) Paint from nature whenever you possibly can, there is no substitute for direct observation of the subject matter.

2) In concordance with the rules of contrasts and atmospheric effects, the colors of the sea and of rocks in the background are paler with fewer contrasts in comparison with the foreground.

3) The white froth caused when the sea washes against rocks or the sand has to be painted from memory. Use latex to mask the white spaces or scratch off the paint afterwards with a stanley knife.

In order to understand the chromatic variations of the sea, one must first of all discard the preconception that the sea is always blue. Of course, it has no fixed color of its own, even though you may believe otherwise. The sea's color is a reflection of that of the sky, so when the sky is bright blue the sea is correspondingly brilliant, if the sky is overcast the sea is grayer; at dusk, the surface of the sea is transformed, appearing orange or purplish. A piece of advice, try to imitate the reflected color as truthfully as possible, there's no need to alter or improve on the reality.

The artist Claude Monet who closely studied the chromatic variety of the sea, wrote about his obsession during one of his visits to England *"Every day I learn a little more about its wil-*

141

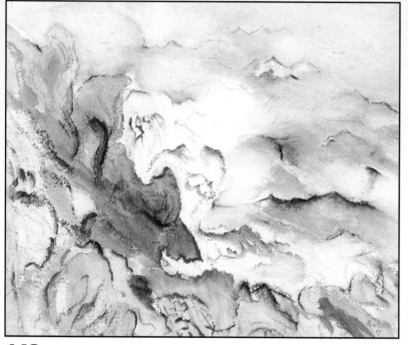

Figs. 141 and 142. Two different interpretations of the sea: *Rocks on the coast of Maine*, John Marin (Columbus Museum of Art), represents the sea as a majestical source of power, capable of throwing itself violently against the rocks (fig 141), while, in contrast, James Abbot McNeill Whistler, in his *Port of Venice* (Freer Gallery of Art, Smithsonian Institution, Washington), sees the sea as a docile and peaceful mass of water (fig. 142).

142

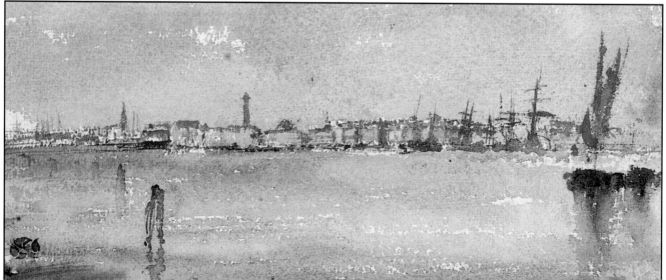

fulness. it drives me to distraction, but at last I understand that, to paint the sea with any accuracy, one needs to contemplate it all day, every day and from the same spot".

As I've already said, put the idea behind you that the sea is of uniform color. As a general rule, the color of the ocean is palest at the horizon where the sea appears to meet the sky, the colors deepen as it approaches the shore. Against the coastline the waters are dark and intense, a combination of rich tones and hints of colors; ochre, turquoise, etc. When painting this area leave white spaces to represent the light rays catching the crests of the water.

143

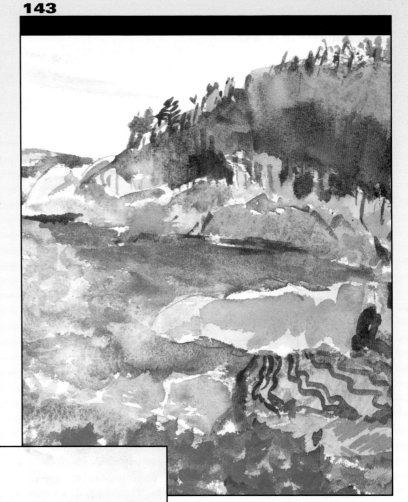

144

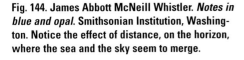

Fig. 143. An artist's impression of the rich variety of colors caught up in the sea's reflective surfaces: John Marin, *The coast of Maine*, Colombus Museum of Art.

145

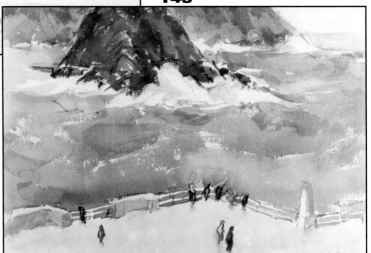

Fig. 144. James Abbott McNeill Whistler. *Notes in blue and opal*. Smithsonian Institution, Washington. Notice the effect of distance, on the horizon, where the sea and the sky seem to merge.

Fig. 145. Manel Plana. *The island of Santa Clara*. Artist's private collection. The sea reflects the color of the sky, so the sky must be covered by clouds as the sea's colour is a rich variety of grays.

When painting a beach, port, or cliffs, you will frequently come across boats which are lying at anchor there. To draw or paint boats simply requires an understanding of their structure, dimensions and proportions, bearing in mind the width of the boat in comparison with its height and length, doubts which can be resolved with a sketch painted with the correct perspective. Once this has been done, it is relatively straightforward to draw or paint the vessel. I will run through the simplest way of learning how to go about it.

Gaspar Romero's study demonstrates how to paint boats at anchor waiting to set out fishing. Being very familiar with the theme, his approach is very direct. With the paper ready mounted on a board he makes a pencil outline of the basic elements of the composition (fig. 146). The pencil sketch is particulary important when making a study of boats, as you need a diagram on which you can build. As often as you can, make a pencil sketch before starting to paint. More on that later, now let's return to the exercise at hand.

Gaspar Romero always starts his watercolors by indicating shaded areas with faint ultramarine blue, a practice common with watercolorists who regularly paint in the open air (fig. 147).

Once the preliminary wash is dry the artist turns his attention to the boats and begins adding details with darker tones. He opts for various pure colors, i.e. unmixed, to define the vessel in the foreground and the little jetty. His palette is fairly limited; unmixed vermilion, red carmine, ochre and Prussian blue. Lastly, with a very light wash, he picks out some details on the horizon line, and on the boats in the middle ground which gives further depth and atmosphere to the painting (fig.148).

Before finishing the exercise, Gaspar Romero has already clearly defined the main subject of the picture, its composition and general shape. From this moment we have two options: give the sketch a more finished

look or continue with further studies like this one.

A stroll in the fishing ports or leisure ports of cities, towns or villages of the Spanish coast is an interesting experience and also offers plenty by the way of interesting material to paint.

146

Fig. 146. The first step is to make a pencil outline of the composition to familiarize yourself with the scene.

Fig. 147. With a little ultramarine blue, begin by putting in the shadows with slight variations of dark tones to suggest the gradations of shadow.

147

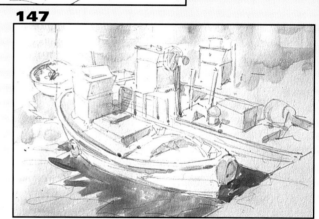

148

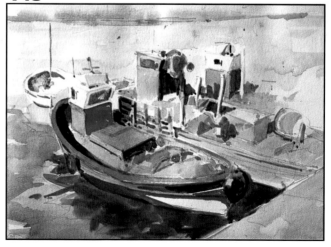
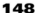

Fig. 148. The study is finished off by using a combination of pure unmixed colors. This is how the finished draft looks.

The effect of reflections on the rippled surface of water has always mesmerized artists. Despite the apparent difficulties of recreating this effect, with a little advice, painting reflections turns out to be relatively easy, although it requires good powers of oberservation. Reflection is one of the effects that most characterizes the painting of seascapes and river scenes, i.e. scenes where the artist includes large stretches of water in the painting.

Any stretch of water acts as a mirror, as a consequence, an object resting on the water's edge will create an inverted reflection. When we try to paint an object's reflection we should project the vertical lines —which determine the height— straight down. The distance to the apex of the reflection will be equal to the height of the object itself.

If the object is lifted above the water, the reflected image will also be displaced in the opposite direction to an equal distance away from the water's reflective surface. This can be summed as follows:

«The distance between a point and the reflective surface is the same as that which exists between the surface and the reflection of the point».

But another complication arises, reflection on a surface with ripples of water. It is very rare that water is completely still, and ripples cause distortion of the images' reflections. This means that we have to add to our explanation the effect produced by lapping waves or the flowing current of a river. If you are lucky enough to live near the coast, a river or a lake, make the most of the opportunities you have to practice painting reflections.

Fig. 149. Adding in reflections is not difficult. *In The port* **by Albert Thompson Bricher, The Brooklyn Museum, New York, the reflection has been painted with zigzag brushstrokes superimposed on the surface. The resulting reflections have very little definition.**

149

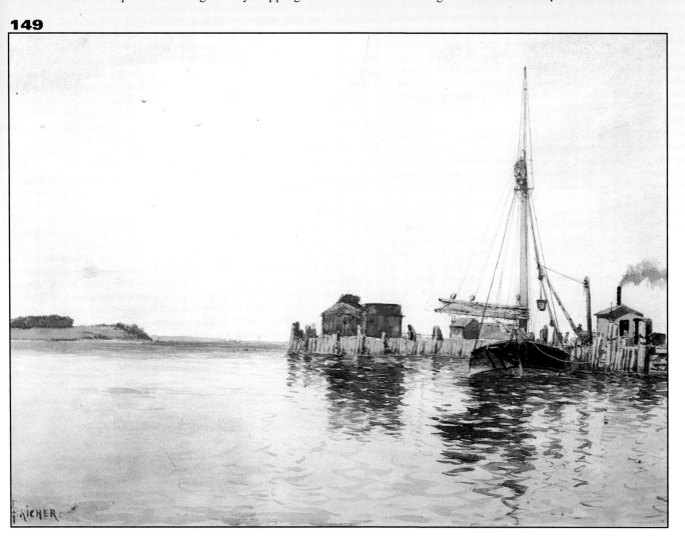

150

151

Fig. 151. Landscapes at night such as *Grey and golden*, by James Abbott McNeill Whistler (Freer Gallery of Art, Smithsonian Institution, Washington), are popular as they provide an opportunity to create magical reflections which are diffuse and ghostly.

Fig. 150. John Singer Sargent. *Venetian scene*. The Metropolitan Museum of Art, New York. The reflection, more detailed in this case, has been created through the echoing of tones and shapes on the surface of the canal.

152

Fig. 152. *Night scene* by Manel Plana (Artist's private collection) confirms what was said about the last image. Here however, the reflections have be created by leaving the paper white.

As we have just discussed, one of the most characteristic aspects of a scene featuring a body of water is the reflections it produces. For this reason, Gaspar Romero will briefly show us how to tackle "troublesome" reflections.

Having made a pencil sketch, the artist starts to paint the subject, in this case a collection of typical Dutch houses on the edge of a peaceful canal. To start with, the artist leaves the water with just a simple very dilute ultramarine blue wash. He starts work defining the collection of wooden houses, in order to paint reflections the object itself must be painted in beforehand. He starts with a selection of monochrome tones giving the buildings structure, light, color and volume, a wash of sienna with a little vermilion for the roofs, burnt umber for the walls and ultramarine blue and Payne's gray to darken some areas (fig. 153).

The next step is to cover the surface of the water with a diluted wash consisting of Payne's gray with a purplish hint (fig. 154). As you can see, in this watercolor by Gaspar Romero, the main difficulty is calculating the height of the houses and other objects on the banks of the canal. All that has to be done is to project all the points to be mirrored straight down, so that each reflection is the same height as the object but inverted. Last, he finishes by echoing the colors of the buildings in the reflections, albeit with a slightly softer tone. It would be more complicated if there were ripples the water, which would further distort the reflected images of the buildings (fig. 155).

These effects create the vibrant sensation of light and colors which flicker across the surface of the water.

Just one thing; when you go to paint seascapes don't forget these principles as there will be reflections in whatever subject you choose to paint.

153

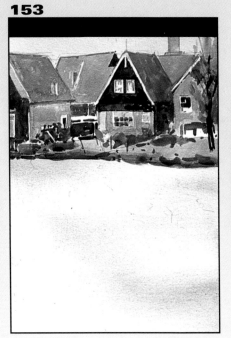

154

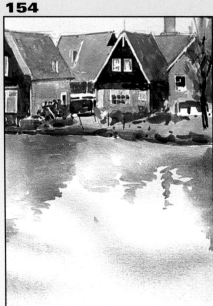

155

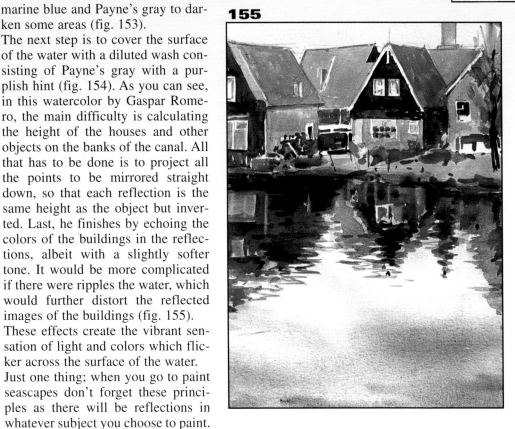

Figs. 153 to 155. It is very simple to see how the artist deals with the "difficulties" of reflections. See how the inverted reflection is exactly equal in height to the building that produces the reflection.

Trees, Bushes and Grass

156

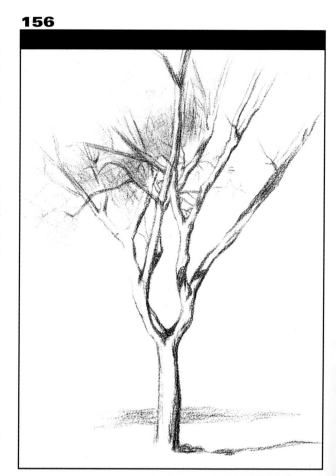

Even before landscape became one of the most popular subjects for paintings, trees have been present in paintings since before the Renaissance. Early representations of vegetation were highly stylized, but thanks to important botanical discoveries in the eighteenth and nineteenth centuries and the Barbizon school which encouraged painting in the open air, the shapes of trees became more accurate.

Studying trees is easy as they are all around us. Also, given their irregular shape, don't be overly worried about balance, there's no need to accurately calculate all their proportions. When you draw trees, bear in mind the synthesis of the whole (very important in this case), which is, effectively, drawing or painting with fewer lines, looking at the subject with half closed eyes to eliminate unnecessary details. It is evident that you cannot draw a tree by trying to include every single mark, hollow, crack, leaf and twig.

«Painting with synthesis means "rationing the details", as Ingres said. Try to look at the tree through half-closed eyes and see only the basic shapes. You should paint with thick brushes so you cannot give into the temptation of overdoing the fiddly work and detail which will derive from the power and spontaneity of the painting».

In watercolor painting there is no need to describe each leaf in a realist manner, you must take this advice in order to avoid the temptation to paint small details which will convert the painting into an academic study. You must simplify.

157

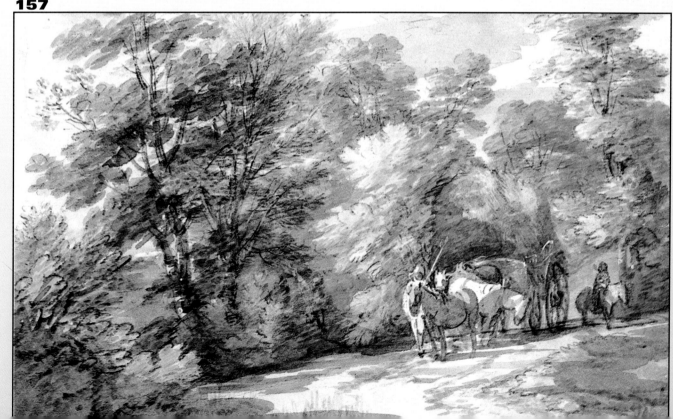

158

So, in order to master the skill of painting trees you must start with plenty of practice making drawings of trees, bushes and scrubland, as Van Gogh did, so that you are able, after a time, to synthesize forms, and are able with a few brushstrokes to describe all the leaves and branches. It is advisable to start off by drawing branches which are bare of leaves in order to study the forms of the branches and trunk; when you get to this point, finish by "clothing" the tree with foliage.

Fig. 156 (facing page). Pablo Ruiz Picasso. *Sketch of a tree*. Picasso Museum, Barcelona
.

Fig. 157 (facing page). Thomas Gainsborough. *Cart crossing a clearing*. The British Museum, London.

Fig. 158. Albrecht Dürer. *Group of plants*. Graphische Sammlung Albertina, Vienna. Dürer's interest in botany led him to make a series of watercolor and gouache studies which look closely at the world of plants and bushes.

Fig. 159. Manel Plana. *The arbor*. Artist's private collection. With the combination of a few colors, greens and blue cobalt, the artist has painted this group of trees with the effects of light and shadow.

159

Given that good painting relies on good drawing and constant practice, it isn't surprising that many artists have filled whole notebooks with landscape studies, in particular sketches of isolated trees and bushes. Artists like Van Gogh, Dürer and Constable all made avid studies of vegetation. Constable made a particularly impressive study of fir trees.

Pere Llobera shows us the best way to approach these studies. There are a number of studies of different types of trees here which help us to look at the challenge of tree studies step by step. Like many artists, Llobera starts by sketching the trees in pencil, in such a way that the trunk and some of the leafy branches are clearly described in a brief pencil outline (fig. 160). With a number 8 sable brush, use a green with a hint of sepia to describe the trunk, branches and the crown of the tree. This can be done with very few brushstrokes. On the wet paper, add the darker tone of green over the lighter green merging the colors in places to create a play of light and shade (fig. 161). Let the paint dry for an instant. When the lighter coat is dry, finish off by adding shadows on the branches using dry brush technique and strengthening the color of the trunk and branches (fig. 162).

160

Fig. 160. Firstly, the structure of the tree and the branches are outlined as a framework for the watercolor.

161

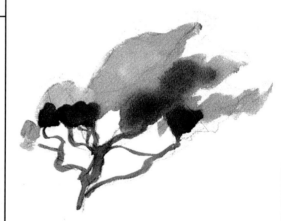

Fig. 161. Pere Llobera continues by painting the trunk, the branches and the foliage with a single layer of green paint. He adds in some further details wet on wet.

162

Fig. 162. Add the light and shadows roughly, with a dark green and strengthen the color of the trunk and branches.

163

You may consider some of the tree studies to be somewhat abstract. When looked at in isolation they are not easily identifiable shapes. However they are transformed into perfectly identifiable trees when put into context in the background of a painting. It is best to do this exercise in the open air, to enable you to use your direct impressions to capture and express the shapes more accurately. You can use the sketches as reference points once in the studio. The way in which you paint trees reveals much about your approach to landscape.

If you want to practice, you'll need an A4 sketch book a 2B lead pencil and a portable watercolor paintbox especially for painting outdoors.

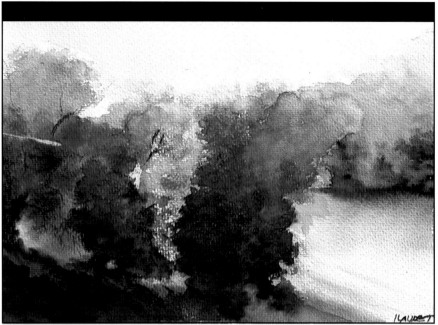

Fig. 163. Trees may appear to be nothing more than abstract blotches. However, when they are integrated into a landscape they take shape. See Ester Llaudet's watercolor as an example (artist's private collection).

Fig. 164. These tree studies by Pere Llobera are exercises in synthesizing forms which focus on capturing the main volumes rather than detail.

164

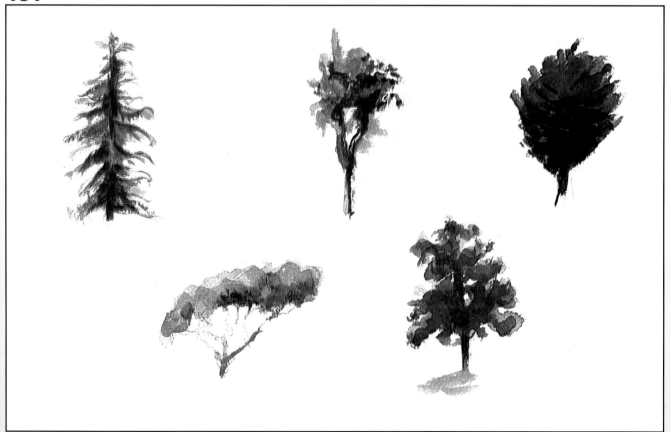

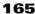

165

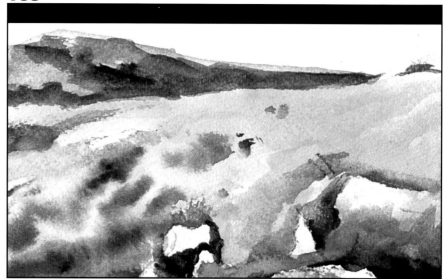

Now study the images on the right, look at their reduced definition and the synthesis of textures and colors of the grassland, plants and verges. This vegetation is painted with blocks of color which synthesize the details, resulting in a picture that borders on the abstract due to the synthesis of shapes and colors. Usually these scenes are painted in a uniform color with tonal variations that give shape to the unevenness of the terrain. Blocks of color which, when incorporated into the context of the picture transform themselves from abstract shapes into clear representations of a patch of grass bleached golden by the sun (fig. 165), grasses and plants that grow along a woodland path (fig. 166) or grass growing on coastal cliff tops (fig. 167).

When painting vegetation growing along roadsides, paths or riverbanks use upward brushstrokes to indicate the direction in which the grass grows (always from the base up, not downwards towards the root). Unlike the uniform treatment of a lawn, such undregrowth needs a higher degree of definition that can be achieved by superimposing brushstrokes. A professional watercolorist will also open white spaces using a fingernail or the other end of the paintbrush on an area that is still wet to simulate the growth of vegetation.

166

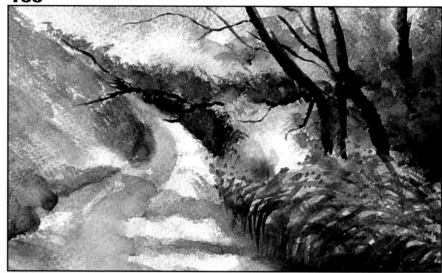

167

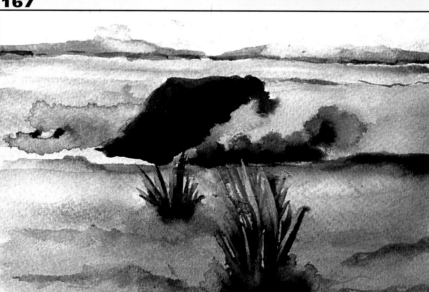

Figs. 165 and 167. When grass, undergrowth or bushes are painted in the distance their appearance should be synthesized to form a uniform block, the closer they are the more defined they should be.

168

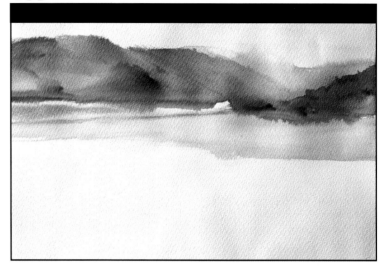

Now watch as Ester Llaudet takes us step by step through the creation of a winter landscape dotted with bushes and vegetation.

After the briefest of preliminary outlines, the artist wets the paper with a wide brush so that she can paint wet on wet. once the paper is wet, she adds a first haze of purplish color to represent the mountains in the background, diffused by the distance. She then adds little touches of green and ochre letting it merge with the wash applied beforehand (fig. 168). Remember that colors in the distance adopt a purplish haze.

The artist decides to leave the sky untouched, as if it were overcast by a layer of very thin uniform cloud, allowing plenty of light onto the scene. She continues by adding another wash, of green this time, to represent the grassland covering the foreground (fig. 169). She lets the paper dry and then adds the the bushy clumps using drier, thicker paint so that their strong silhoutte stands out against the pale background of the earlier washes (fig. 170).

I've already mentioned that synthesis is crucial when painting vegetation, and in this example is used in depicting the bushes in the middleground with rough brushstrokes; in contrast, the foreground detail is more decisive, with well defined strokes, so that the details are more evident: the foreground vegetation is in clearer focus and lots of detail has been added. First the shape of the dark green plant is painted and then the details are added with a thinner brush using denser colors (fig. 171). Even so, the details are hardly more than abstract, and nothing is depicted with minute detail.

169

170

Fig. 168. The artist begins the watercolor by putting in the farthest planes, gradually progressing towards the foreground.

Fig. 169. She continues by adding the sea in the middleground and then the foreground covered in a patch of grass.

Fig. 170. The upward brushstrokes used to depict the vegetation are very effective.

Fig. 171. Compare the vegetation painted in the middle ground to the more detailed foreground vegetation.

171

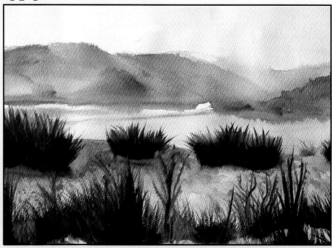

Figures in Landscape Painting

Whenever you paint an urban landscape you will doubtlessly encounter plenty of people, some stroll past, others sit peacefully reading or enjoying the sun, etc.; however, when you are in the middle of the countryside, on cliffs or on a hillside, the presence of people will be sparse and their inclusion in the scene will depend on the criteria of the artist.

Figure sketches in watercolor should capture the moment, their impression should bc of spontancity, imagination and originality. These sketches have various purposes; to discover and understand which different postures and positions are aesthetically pleasing; to learn how to capture the appearance by close observation of human postures, and improving your drawing skills.

In order to learn to paint you have first to learn to look. Figure sketching gives you the opportunity to learn how to observe and understand human postures, and it is only possible, to strengthen the link between the eye, the mind and the hand through observation and practice.

You are likely to encounter difficulties in including figures in landscapes as they are usually mobile. If you find this difficult, I suggest that you concentrate on these sorts of sketches. You have to work rapidly, leaving aside detail and concentrating on interpretation of the model. In other words, paint using sweeping strokes adding only a few touches. This method requires working at speed, capturing essence rather than accuracy.

172

173

174

175

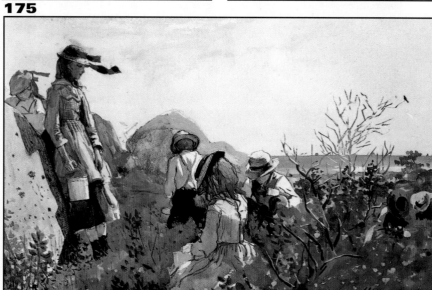

Figs. 172 to 174. Study these figure sketches by Merche Gaspar, and make some of your own. Start with stationary figures then move on to drawing or painting sketches of moving figures.

Fig. 175. Winslow Homer. *The berry pickers.* Colby College Art Museum. Much of this artist's work includes figures set among landscape.

This exercise by Merche Gaspar is a clear example of what we have been discussing: interpreting figures through synthesis. This study captures the freshness and spontaneity with wich the aritst interprets the figures.

Start, as usual, with a number 2 pencil, outlining the group of figures without including much detail (fig. 176). If you do this exercise from life, I suggest that you pick seated figures which are more likely to hold their position for longer; you can then progress to moving figures, trying as you do, to memorize what you see in order to be able to complete your drawing from memory using a reduced number of strokes.

The artist uses a number 10 brush to sweep the ground with a gray wash and with touches of ochre and red carmine she adds the skin color of the figures (fig. 177).

She then focuses on the figures one by one, contrasting dense and light washes, briefly sketching feet, arms, a face, a hat, introducing other tones for the heavily shaded figure in a jacket on the right (fig. 178). Continue with this exercise in synthesis in the same way. The gathering of people behind the foreground figures are added in with rough brushstrokes, in an abstract way, which suggests their constant movement (fig. 179). There are no facial features, the people are unidentifiable and there is no need for further detail in such a sketch. In fact, it would be a waste of time to try and describe their features.

Painting figures with this degree of confidence is a challenge which requires a great deal of practice.

176

177

178

179

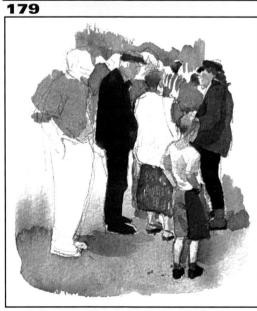

Figs. 176 to 179. Study this group of figures painted step-by-step by Merche Gaspar. It is sufficient to capture your first impressions with a pencil outline, then you can try to memorise the colors and paint the group. Alternatively, it is easier and more convenient to paint from a photo.

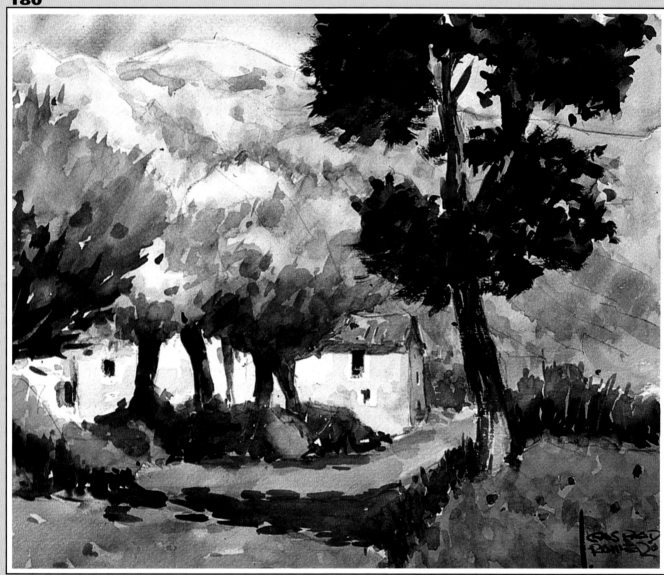

Fig. 180. Gaspar Romero. *Path*. Artist's private collection. This watercolor, developed step by step on pages 83 to 85, is a good example of how to approach painting grass and trees, and how to integrate these elements into the landscape.

PRACTICING WATERCOLOR LANDSCAPES

We have reached the last chapter of this book, the aim of which is to explain practically and clearly the information covered in the previous chapters. This will help widen your understanding of the practical techniques of watercolor landscape and how to consider the peripheral details. So, from here onwards you take the lead and put your skills to work. I very much hope that you will follow the step-by-step exercises that I explain with the help of paintings by professional watercolorists.

We will touch on a variety of themes such as how to paint skies and clouds, painting grass and trees and copying a Dutch landscape using a more contemporary approach. It's time to get your hands dirty!

Pencil and Watercolor Sketches

181

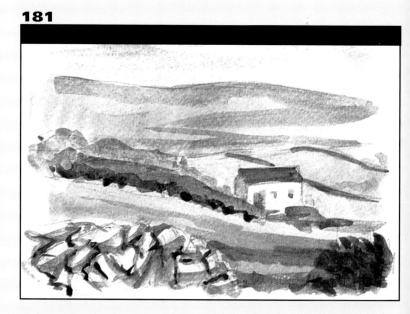

The French artist Maurice Denis wrote the following to Helmut Ruheman, also a painter: *"Before beginning a painting, make a small, rapid sketch of the composition and color scheme, and don't be tempted to deviate from your initial impressions for anything in the world"*.

It is best to cover a diversity of subjects when you sketch landscapes to enable you to practice all the different contrasts, shapes, volumes, textures and tonal variety.

You will find this a useful way of gathering information for future works. Perhaps you will find these studies complicated at first, but persevere and your practice will help you further understand the issues of form, structure and format of landscape painting. In addition to notes on landscape painting, you may produce a definitive work of art.

Figs. 181 to 183. Whenever you set off for the countryside or the beach always take a sketchbook with you as sketches will be invaluable to you when attempting a large scale work. With this in mind look at the *Irish landscape* sketch by Ginés Quiñonero (fig. 181) and *Tropical beaches* by Merche Gaspar (figs. 182 and 183), artists' private collections.

182

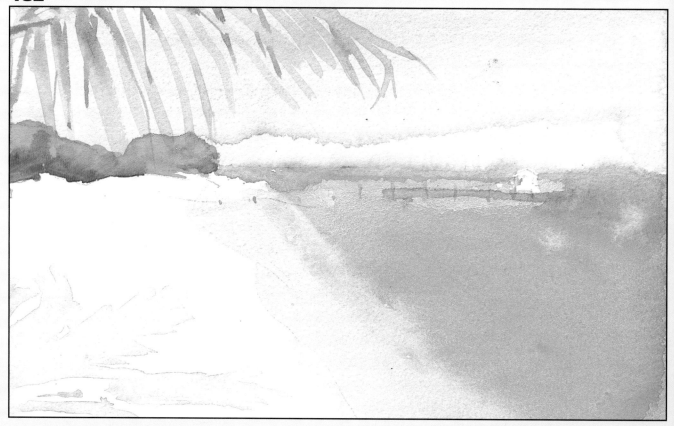

183

Clifden 1991

Always remember:

To paint well with watercolors you have to draw well.

Taking notes in watercolor is a basic exercise which helps you consider the best format for the picture, the potential of the subject in terms of composition, contrasts, colouring and interpretation. A study should be an approximation in which the artist synthesizes the essential motifs of the scene, not troubling with details and subtleties and working *alla prima* (quickly, without retouching). This provides an opportunity to experiment without worrying about mistakes; sketches are simply lessons, they can be discarded if they go wrong. Bear this in mind and you will work more freely, with more spontaneity. A good sketch should take you less than fifteen minutes; imagine how many you can do in a good session.

The choice of theme is never a problem, any corner, any object, however unexotic, will serve its purpose. Take your sketchbook with you every-

184

185

186

where, to the park, the beach, up to a hilltop or out onto your balcony or garden. Cultivate the impulse to create, don't be hesitant to sketch wherever you find yourself.

To improve your skills in watercolor painting you will have to work at this type of sketching whenever you can and, with constant practice your brushstrokes will become more confident and you will improve your powers of observation and develop your skills in synthesizing what you see.

I recommend that as well as a small sketch book you take three or four colors at most, a couple of brushes and a little bottle of water (not always easy to find when you are out in the open). With these materials, head off towards a park or any green space and I assure you you'll find a suitable scene to get to work on.

187

188

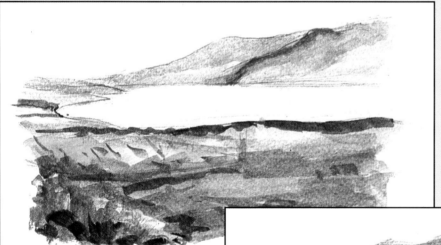

Figs. 184 and 185 (facing page). Summer holidays are a good excuse to explore sunny coastal cliff tops or undulating farmland. The examples on the facing page are painted in Spain, *The cove*, and *The ravine*, by Ginés Quiñonero (artist's private collection).

Fig. 186. Some blocks of color and a few pencil lines recreate the atmospheric scene, *In the woods*, Merche Gaspar (artist's private collection).

189

Figs. 187 to 189. These three studies conjure up the beautiful Irish landscape as depicted by Ginés Quiñonero. See how a few subtle washes of color are sufficient to recreate the undulating fields and mountains, any further detail would be superfluous.

Painting Cloudy Skies

190

191

Pere Llobera is going to show us how clouds are painted. As a warm-up, he starts with a quick study of a half overcast sky and a silhouetted mountain without any visible details (fig. 190).

Let's see how he goes about it. Having wet the paper, the first marks he makes on the paper are grayish and having been applied to wet paper they spread freely across the surface creating an irregular pattern characteristic of clouds. The little patch of blue is created by adding a diluted blue to the lower left quarter of the sky (fig. 191). Now, painting with a mixture of burnt umber, ultramarine blue and red carmine red the mountain's profile is added at the bottom of the picture plane, a strong, dark block of color at the base of the scene (fig. 192). He then returns to the clouds, adding the color in strokes, letting the paper absorb it, leaving it to chance where the random drops of paint will run.

Finally, and most importantly, the artist shows us how to enrich colors and textures by superimposing layers of washes in such a way that, when the paper is dry the contrasts will hardly be noticeable. He then makes the blue patch more intense. See how simultaneous contrast makes the clouds above seem whiter. And, the final touch, he darkens the clouds at the top of the picture plane, again creating a contrast with the white clouds in the center (fig. 193).

192

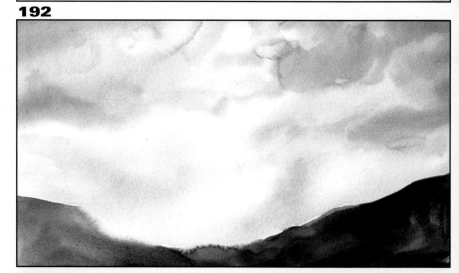

193

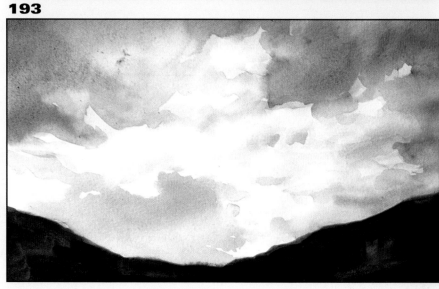

Figs. 190 to 193. The breakdown of an exercise in painting a cloudy sky (fig. 190), white and gray clouds jostle leaving patches of blue. A good choice of subject for a watercolor.

195

194

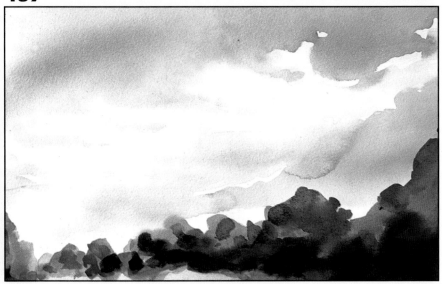

196

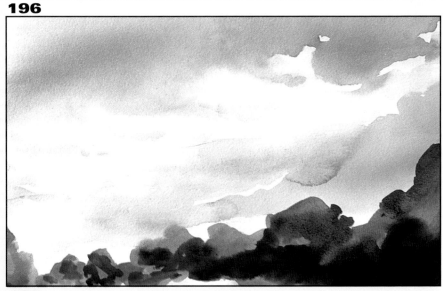

197

In the next example, a clear sky has one cloud cutting diagonally across the picture plane. In the foreground we can see a road on the edge of woodland (fig. 194).

Pere Llobera is going to use the same method as in the previous exercise, but here he gives more finish and detail to the foreground elements.

Without doing a previous pencil outline, he paints in the blue curtain of sky with a watery ultramarine blue at the top of the picture and cobalt blue in the center, leaving white spaces on the paper for the clouds. With a little Payne's gray and blue he adds a dilute wash in this area to suggest the shadows on the underbelly of the cloud (fig. 195). Having worked on the sky, he turns to the trees growing along the verge of the road, adding color by starting with a wash of yellow ochre, emerald green and Van Dyck brown. Then working wet on wet, he picks out darker patches of color by adding dashes of violet and Payne's gray to the mixture in order give depth to the foliage (fig. 196). Llobera doesn't use rag to absorb the excess water or color, he always uses absorbent paper which acts like a sponge.

Figs. 194 to 197. When you paint landscapes (fig. 194), you should always start with the sky, as Pere Llobera does here. Work from the top downwards. Remember that the sky is an extremely important element of the picture which gives light to the scene, and depending on its appearance it will affect the landscape which lies below.

With very diluted ochre he adds the road, covering the white space which, if left, would detract from the whiteness of the cloud highlights. (fig. 197, previous page)

As you can see, the artist has achieved this effect on the vegetation by adding successive layers of brushs-trokes, from light through to dark, to give them the depth and variety they need. When you are trying to paint this sort of vegetation, it's better to suggest the shapes than to analyze each detail. Unlike the previous phases, detail is added to the trees by superimposing layers of different color over an already dry wash. Llobera uses sienna with a purplish hint to add the shadows that the trees cast on the road (fig. 198). He then turns his attention to the sky once more, adding brushstrokes of ultramarine blue to the soft blue background. He gives the clouds more shape, redefining their edges and picking out the areas of shadow creating stronger contrast and highlighting the white areas (fig. 199). A number 12 brush, a mixture of synthetic fibre and sable, was used for the first blocks of color, the finer details of the trees were painted with a number 6.

Here we can see the final result: having added the finishing touches to the color of the clouds and the trees on the side of the road, he has deepened the shadows cast by the trees. The final touches balance out tones and harmonize the scene (fig. 200).

198

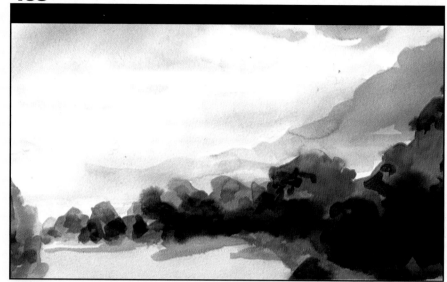

199

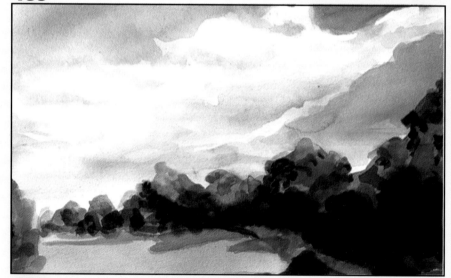

200

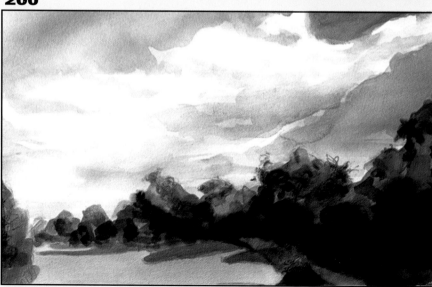

Figs. 198 to 200. You should make studies of skies following Pere Llobera's method. Use photos for your first studies and then venture out to paint in the open air. The location of your sky study is unimportant, anywhere will do.

Painting Grass and Trees, Step-by-Step

201

Gaspar Romero is going to paint a watercolor of a rural scene, the view of a path leading past a farmworker's house. There is plenty of greenery on the verge so it will be a good exercise in how to tackle the various textures of grass and trees in a landscape.

He begins by drawing a pencil sketch of the subject, outlining the main feature (fig. 201). He continues, as he normally does, by adding in the shadows with a combination of ultramarine blue and cobalt blue. This first step in watercolor helps build the structure and the subject takes shape. Adding the shadows at this stage avoids the problem of constantly changing light, which occurs when painting outdoors for any length of time (fig. 202). He starts work on the center, with light washes of reddish paint for the roof, cream for the side of the building and gray for the base of the outside walls. With a darker gray he adds the openings of the doors and windows (fig. 203).

Gaspar Romero usually paints from the top downwards, starting with the sky, with the same blue used for the shadows, and continuing with the

202

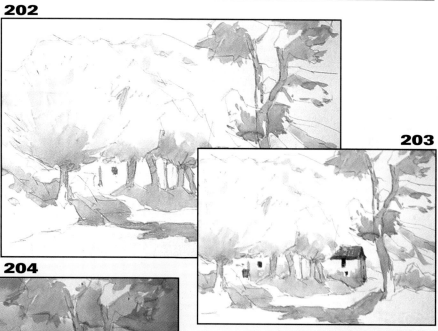

203

204

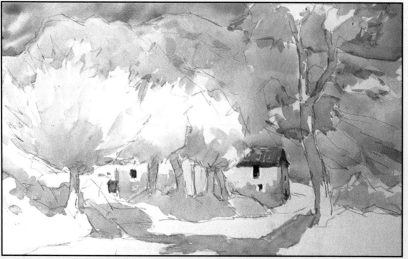

Fig. 201. Gaspar Romero's pencil sketch, a fine example of simplicity and synthesis of forms.

Fig. 202. Gaspar Romero paints his shadows with a bluish tinge, shadows are predominantly this color.

Fig. 203. With few colors and a number 6 brush the artist nearly finishes the building.

Fig. 204. The moment when an extensive wash of Payne's gray is added to darken the mountains and give them a rocky appearance.

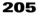

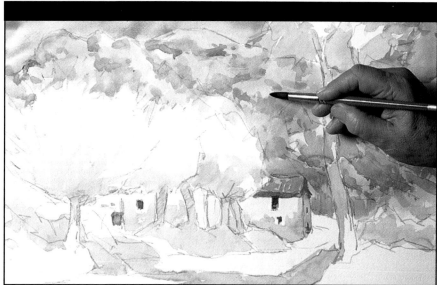

gray mountainside which serves as a backdrop to the building (fig. 204, previous page). Hardly letting the first wash dry, the artist adds the relief and shadows to the rockface with a number 6 brush, he uses a more purplish gray, darker than the wash beneath (fig. 205).

He then moves on to the middle ground, painting the trees first with a light green wash, then adding a darker green to the parts in shadow, and the trees take shape. The patch of grass growing in the shadow of the trees is painted next using a more yellow green for the areas bathed in sunlight (fig. 206).

Next he works on the tree on the right in the foreground, starting by giving volume to the foliage using the contrasts of light and shade. He continues in the same way with the road (fig. 207). Then the trunk is painted with diluted burnt umber and a touch of ochre and he adds more detail to the crown of the tree with brisk, irregular brushstrokes which deepen the speckled color of the foliage (fig. 208, facing page).

206

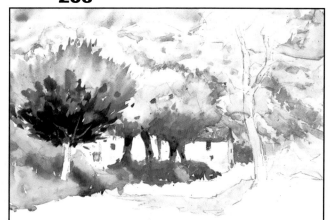

Fig. 205. The mountains in the background are shaped using wet on wet; adding wet paint to an underlying wet wash.

Fig. 206. The trees take shape. He starts by painting the trunks and branches, and continues with the foliage, building the volume by adding shadows to the shaded parts of each tree.

207

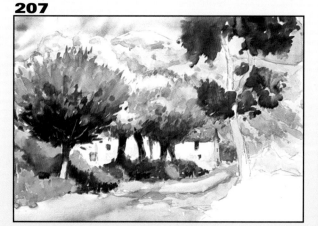

208

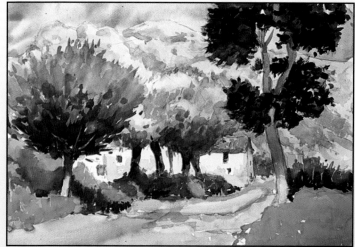

Fig. 207. The artist begins work on the tree in the foreground: a good moment to see the methods discussed earlier put into practice.

Fig. 208. Work continues; when the layer of paint is dry the artist paints over the top with brisk brushstrokes, creating shadows and depth on the crown of the tree in the foreground.

209

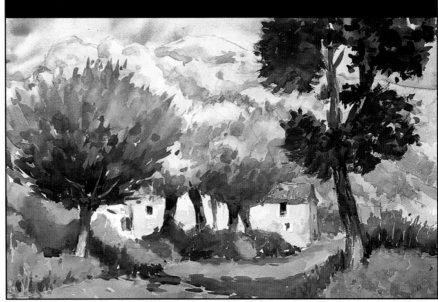

The artist is adding the finishing touches. He includes the shadow cast by the closest tree (using sepia with a purplish hint) adds volume to the grass with short upward brushstrokes of a slightly darker color (permanent green with a touch of ochre). With a second wash he darkens the tree trunk in the foreground. He also enriches the color of the road and adds some little rocks in the foreground, having left lighter spaces when completing his second wash (fig. 209).

The finished rural scene can be seen below (fig. 210) signed by Gaspar Romero. In the foreground see how this skilled watercolorist has incorporated some red splashes of color, poppies, adding a touch of strong complimentary color in a chromatic scale rich in greens.

Fig. 209. The painting is practically finished; this is the moment to stop and consider what's been achieved and whether anything requires further work or correction.

Fig. 210. This is a fine watercolor, its qualities lie in the representation of texture; the grass and trees, and its rich tonal diversity giving the work depth and substance.

210

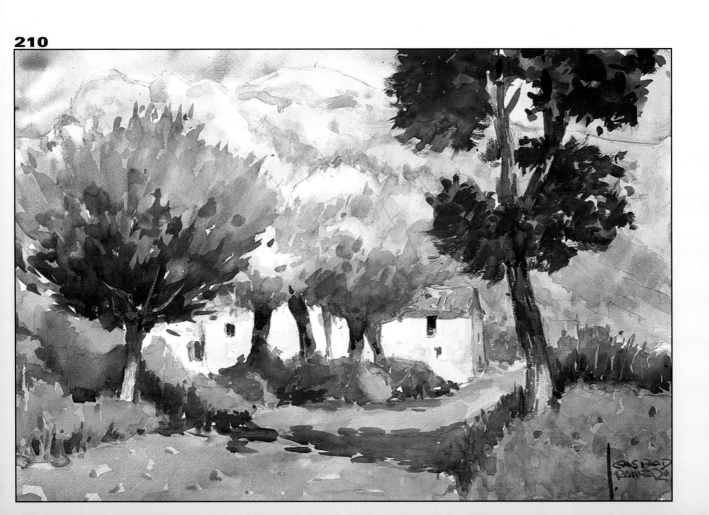

Painting a Copy of a Dutch Landscape

Landscape painting developed as a genre during the sixteenth century and since then it has continued to be one of the most important themes of watercolor painters. In the following step-by-step exercise, Ester Llaudet will interpret Jacob van Ruysdael's *Road crossing fields of wheat near Zuider Zee* (fig. 211). As you can see, the artist puts his very soul into the landscapes he paints. Here, the sky is the most powerful and expressive part of the painting, with breathtaking chromatic effects of color and light caught in the clouds, the sky which contrasts strongly with the ground which is thrown into shadow, making elements in the foreground hard to recognize.

The first step Ester takes is to quickly outline the subject in pencil.

211

212

213

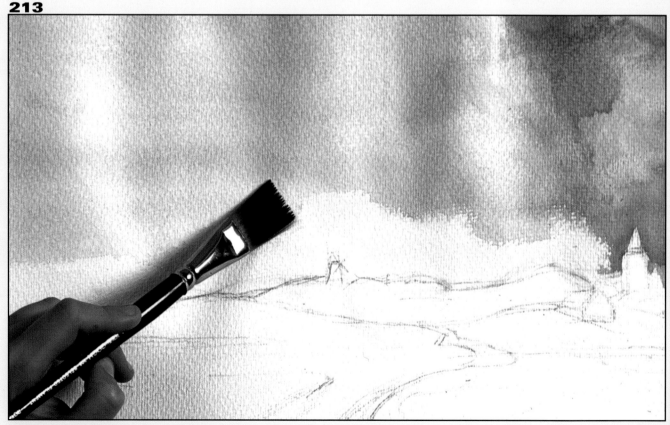

This task must be done accurately as errors at this stage cannot be rectified later (fig. 212 facing page). If you normally scribble a sketch as a guideline, be aware that in this case it is crucial to preserve the same proportions and details. She takes a wet number 14 brush and with very dilute ultramarine blue, applies a wash to the sky. Onto the wet paint, she applies a combination of ochre, red carmine and permanent green with a number 6 brush. Then she starts to build the shapes of the rounded clouds (fig. 213). Ester moves on, progressing steadily, working from right to left (fig. 214). See how, during this first phase the artist has enriched the colors, creating stormy clouds using shades of ochre and orange in the central group. Her small, irregular brushstrokes shape the clouds, considerably increasing the relief effect and stressing the contrast of the colors (fig. 215).

The next step is to add, with a number 10 brush, the road and the land in shadow with a dense wash of sepia, leaving a white space on the left where the field is to be painted.

214

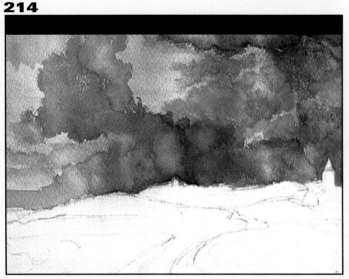

215

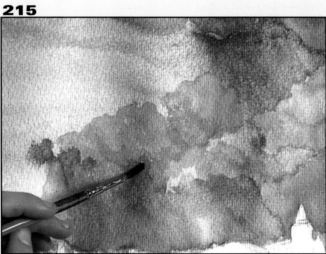

216

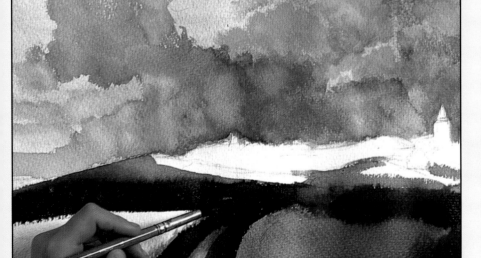

Fig. 211 (facing page). The work to be copied: *Road crossing a field of wheat near Zuider Zee* by Jacob van Ruysdael (Thyssen-Bornemisza Museum, Madrid).

Fig. 212 (facing page). This kind of work requires a precise and detailed pencil sketch, the artist hasn't sketched the clouds, but do so if you feel it will be helpful.

Fig. 213 (facing page). The light blue wash is applied to the sky, Ester then starts to add the dramatic clouds.

Fig. 214. The first stage underway, the sky is replete with a variety of colors, the artist has juxtaposed complimentary colors to increase the expressiveness and drama.

Fig. 215. Having added layers of uneven strokes of color, the tones and shapes of the clouds are developed and the configuration takes shape.

The large dark areas on the road and borders are painted wet on wet (fig. 216, previous page).

At this stage, the copy has its own synthesis; a free reinterpretation of the original. The contrasting shapes, the recession of the road and the bright fields, incorporate a sense of depth into the landscape (fig. 217).

She now paints a wash (lemon yellow, yellow ochre and a hint of vermilion), over the wheat fields in the middle ground and the field on the left in the foreground, and adds the silhouette of a large tree, close to the viewer, in the same sepia color used on the road. The color is applied wet on wet causing the darkness to seep a little into the surrounding yellow, creating an irregular profile characteristic of this sort of vegetation (fig. 218).

Once the sky is dry, she continues to add to the shapes and colors of the

217

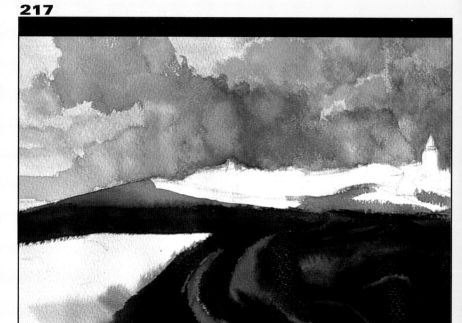

Figs. 216 and 217 (216 previous page). Copying the original, the artist adds a series of dark washes which give relief and volume to the land. Patches have been lightened with a little water.

Fig. 218. The work is taking shape, a dramatic combination of soft ochres and intense sepia of the fields.

218

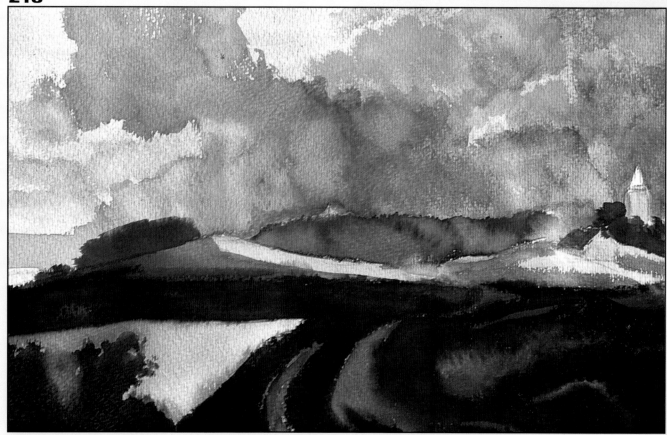

clouds. She tints the strip of trees on the horizon with color, burnt umber, yellow and Payne's gray.

See how the tops of the trees are softened by the wet on wet technique so that there is no sharp dividing line between the trees and the sky.

Next the artist takes a number 3 brush to paint the cluster of buildings that can be seen in the distance, adding details such as doors and windows at the same time. It is very important to keep alternating the thickness of your brushes when necessary. The last details give the work its definitive character. Look for the tiny figures; a farmer and a cow, on the road in the foreground (figs. 219 and 220). The artist starts by adding seemingly abstract blobs of paint and removing excess color by touching them with a finger (fig. 219). Despite their vague appearance the figures will take shape, she adds rough details to them using subdued colours that harmonize with their surroundings (fig. 220). Look back over the section discussing figures incorporated into landscape in an earlier chapter.

The painting is now finished, all she has to do is sign it. And there you have a complete lecture on the painting of a watercolor; a step-by-step account of techniques to use and what to consider when copying the work of a Great Master. Further complicating matters is the fact the original is an oil painting, and certain effects had to be translated from one distinct medium to another (fig. 221, following page).

Ester spent about three hours on the painting. The time you need depends on the choice of subject. As a rule, copies take more time as you have to make a huge effort to accurately copy each one of the elements that make up the scene.

219

220

Figs. 219 and 220. See in this sequence how Ester Llaudet introduces the figures onto the road in the foreground: first she adds little blobs of color, removing excess paint with a finger so that they don't draw too much attention (fig. 219); finally, a few more brushstrokes give the figures a little more definition to make their forms recognizable (fig. 220).

221

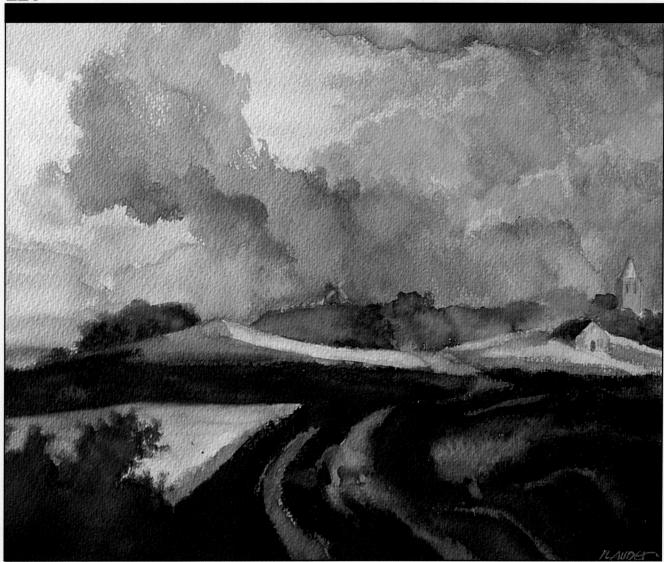

Fig. 221. The finished copy. In this case the
signature is not of prime importance. If you decide
to add your signature, bear in mind that it should
not detract from the composition as a whole.

Painting a Landscape in a Contemporary Style

Gaspar Romero will help us to interpret this scene, a view of a town at the foot of a mountain range, surrounded by rocky steppes and arid fields. The paper he uses for this exercise is 50 cm x 65 cm.

As we've seen previously, the artist starts by outlining the subject in a pencil sketch to define the structure of the scene. He works swiftly from start to finish, making few corrections, with a continuous line, hardly lifting the point of the pencil of the paper (fig. 222).

He then adds a very pale wash to the shadowed areas, using ultramarine blue as usual. The play of light and shadow is established at this point.

The paper is then turned upside down and the sky is painted in with a number 14 brush. First a wash of water is painted to wet the paper, then, when it has been absorbed, a dilute wash of Payne's gray with a touch of cobalt blue is added to silhouette the profile of the mountains. Any excess wash runs downwards. Painting upside down serves two purposes, firstly so that the color of the wash runs down to accumulate on the upper edge of the sky, leaving the horizon line lighter, and secondly so that the drops of excess paint do not run down over the rest of the work (figs. 224 to 226).

Fig. 222. Finding a suitable format and viewpoint are two important decisions that have to be made before embarking on a watercolor painting.

Figs. 223 to 226. Having added a preliminary wash of shadows, Gaspar Romero decides to paint the sky. In order to do this he turns the paper upside down so that the wash is paler where it meets the mountains, gradually darkening towards the top.

227

With a dry paintbrush and with the help of the blotting paper, he emphasizes the white spaces among the clouds by adding subtle tones while the paper is still wet from the last wash.

With the sky finished, he starts work on the mountains in the background. He does this using a pale gray to break up the paper's white surface. Taking a thinner brush, a number 6 and using a wet brush technique, he captures the relief of the rocks and the vegetation by introducing dashes of purplish gray near the peak, altering to a browner tone further down where it disappears behind the roofs of the houses. These phases are all completed wet on wet.

He continues, without pausing, to add the colors of the vegetation which is just behind the cluster of houses (olive green, raw umber, sienna), covering the paper in darker tones and eliminating inaccurate contrasts (fig. 228).

228

Fig. 227. The artist works on varying the tones and hints of color within a range of restricted colors.

Fig. 228. He paints a medium-dark wash of greens and browns in the area between the mountain face and the buildings which helps eliminate simultaneous contrasts.

Take a close look at the following passage which explains how to paint a tree using wet on wet technique. Gaspar Romero takes the paintbrush number 6 and covers the area with a fairly dense wash of permanent green (fig. 229). Without letting the wash dry he continues by adding a second color, olive green with a hint of och-re. See how the wash creeps across the wet paper (fig. 230). Without pausing, he adds a third dark color (permanent green with a touch of Prussian blue) over the lighter wash, painting from the top downwards. The strokes create a synthesis of colors producing a delicate contrast of light and shadow as the wet paints merge (fig. 231).

Figs. 229 to 231. A sequence explaining how to paint a tree with wet on wet technique. Hardly letting the first layer of green dry, add successively darker layers to the foliage, applying a layer of ochre, finishing with a third darker zone to indicate parts of the tree in shadow.

229

230

231

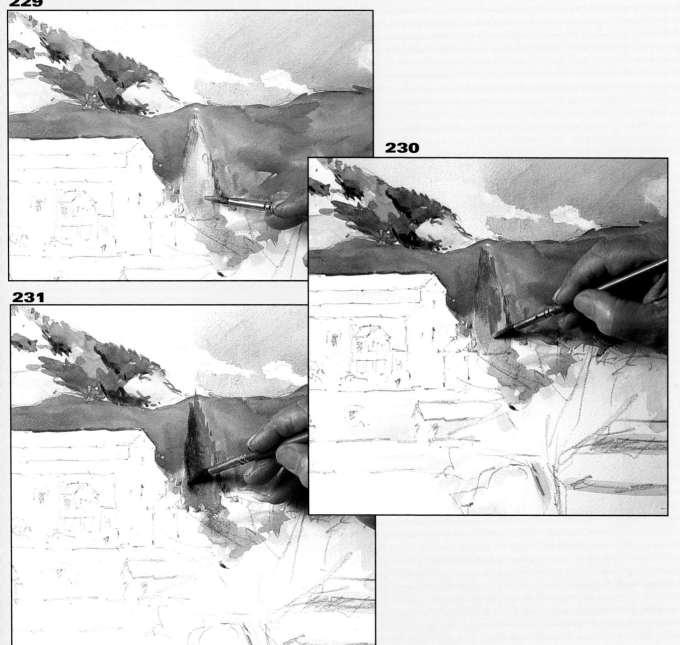

232

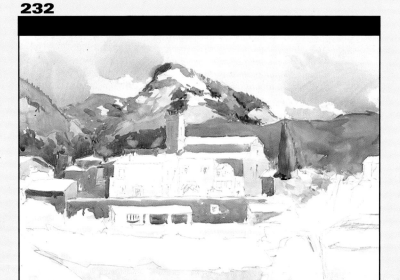

The walls of the church and the group of houses on the left are painted with various tones of ochre, as is the wall which separates the houses from the fields (fig. 232). Next he turns to the roofs, picked out in red carmine with a touch of ochre; and the walls of the closest buildings which are shaded with a gentle gray touched with purple. He also adds detail to the row of sheds in the middle ground.

Finally he adds the doors and windows with a number 3 brush, suitable for adding the tiny, intense concentrations of color (fig. 233). See how the colors of the vegetation on the mountainside frame the outline of the houses in front.

Next the artist works on the large white space in the middleground, transforming it into cultivated fields with ochre and umber tones. On the edges of the field he adds some brisk brushstrokes, without adding too much detail to the clumps of grass there. All that's needed is a wash of light green onto which he adds hints of chiaroscuro (fig. 234).

Next he paints the tree in the foreground (fig. 235), first with a layer of light green, onto which he adds hints of light and shadow, merely suggesting its form, its branches obscured by leaves.

233

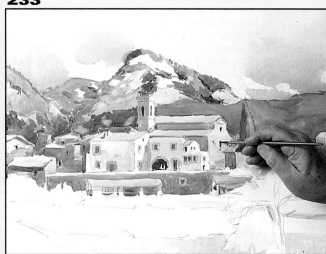

234

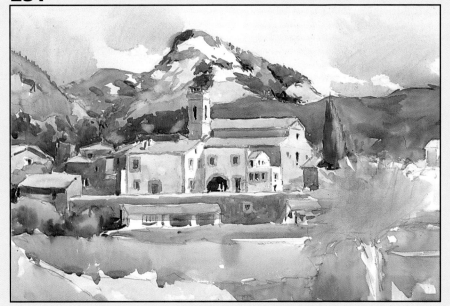

Fig. 232. The watercolor, once some of the key elements have been addressed; the sky, mountains, a group of trees in the background and the blocks of shadow on the group of buildings.

Fig. 233. In the next stage, colors and contrasts have been established among the group of houses; the walls, the roofs and the doors and windows. White spaces left unpainted contrast with shadowed areas giving volume to the buildings.

Fig. 234. The painting is almost finished, except for the foreground which needs more detail; the wheat field needs another wash of color, the tree and the path on the left need further developement.

If you compare this image with figure 234 on the previous page you will see that, except for the final touches to be added to the tree in the foreground, there is not much left to be done.

There are, however, little details such as darkening the windows and doors of the buildings, painting in shadows by the road on the left, giving more definition to the trees in the middle ground, the mountainside, and to the group of houses on the right (fig. 236).

The artist takes a step back from the picture to take a better look and consider whether he is satisfied with it. Now all he needs do is sign it. Take a close look at the finished work and see how the layers of color are applied and how the colors bring the work to life. The picture still retains a certain spontaneity; the fresh look of a contemporary landscape.

Fig. 235. Notice how the artist uses a gamut of different tones, carefully varying the fields in the foreground with layers of wash.
Fig. 236. The finished work. The trees and bushes in the middle ground are now more defined than those further away, and their colors are warmer with a tendency towards ochre and yellow, compared to the others which have a grayer tone. The artist is using the principle of near and far colors to evoke a sense of depth in the landscape.

235

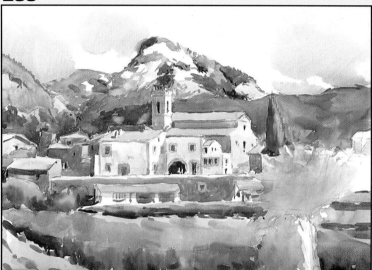

236

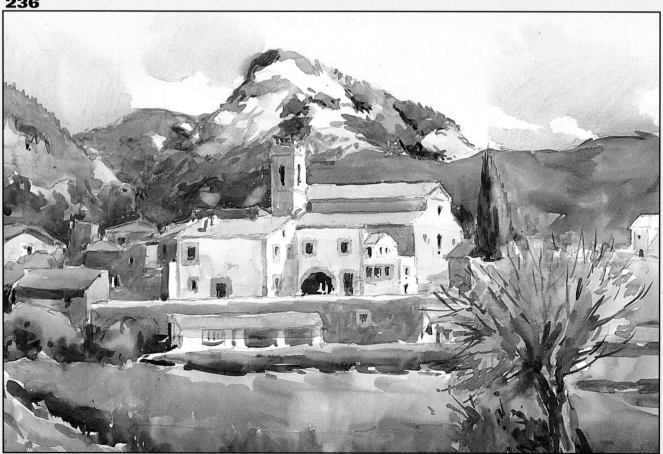

Acknowledgements

The author is grateful for the help and collaboration of the following individuals, groups and companies in the production of this book: Estudio Orofoto for reproducing the materials and photos for the step-by-step watercolor studies painted by artists to be listed later; Manel Úbeda from Novasis for his help in the edition and production of photographic materials and photosetting of this book, and to the artists José Gaspar Romero, Merche Gaspar, Ester Llaudet, Pere Llobera and Carme Porta for the watercolors produced especially for this book.